To John
with all our
love birthday

Douglas Kirkland

DOUGLAS AND FRANÇOISE KIRKLAND

PHYSICAL POETRY ALPHABET

STARRING

ERIKA LEMAY

FASHION DIRECTOR
SIMONE GUIDARELLI

ELEMENT DESIGN
WILLIAM THOREN

SYLPH
EDITIONS

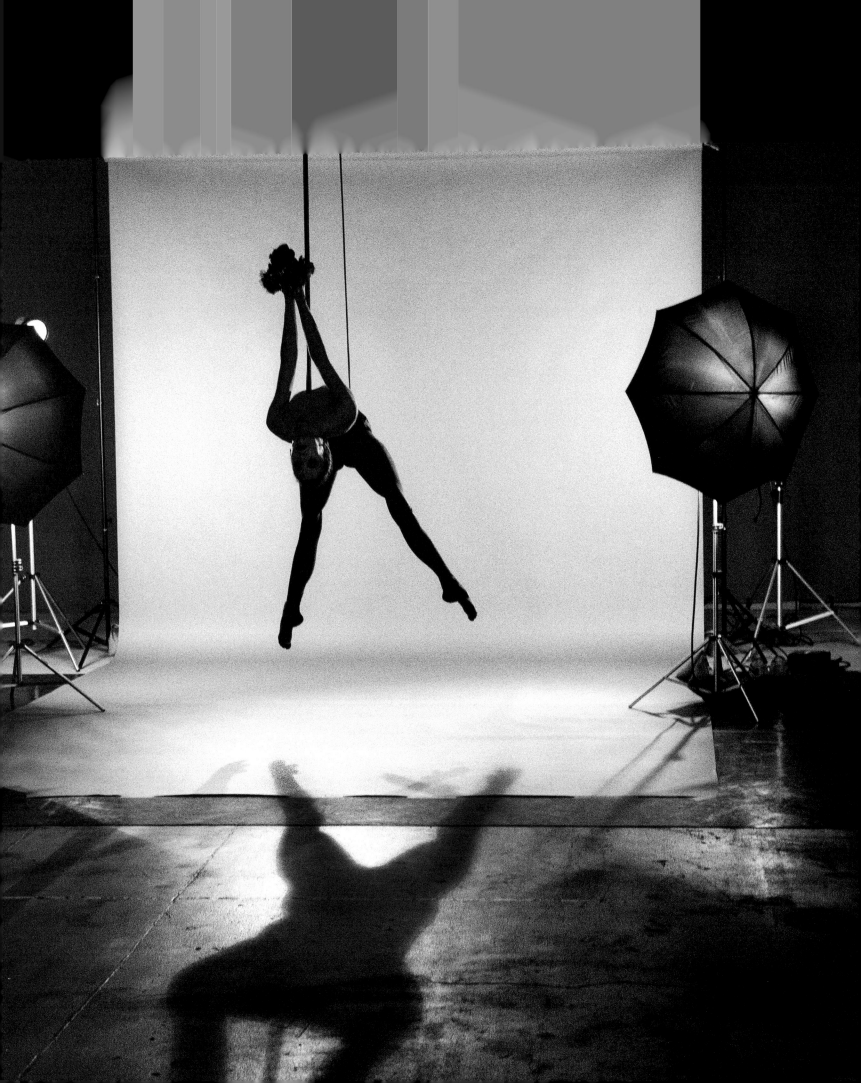

Contents

ORNAN ROTEM
Letter Physique · 7

THE LETTERS A to Z
Physical Poetry Alphabet · 19

ERIKA LEMAY
Dancing in the sky · 76

WILLIAM THOREN
Element design · 80

FRANÇOISE KIRKLAND &
L'inspecteur des travaux finis · 84

Letter Physique

HE ABILITY TO RECORD language through a set of graphic marks – writing – is a unique feat of human ingenuity. It marks the transition from pre-historic to historic, and in literate societies, it is one of the first steps in a child's transition into adulthood. To speak is natural; leave any newborn among adult speakers and within several years, as if of its own accord, the child will speak any language it is exposed to, regardless of how complex or how difficult adults deem this language to be. However, no one anywhere will simply 'pick up' writing merely by being exposed to it: it demands deliberate instruction, patient training, and no small measure of discipline. It can be a joy and it can be painful, but once it's there, it never goes away and reigns mightily over our intellect.

Ever since people have been writing, they have, at the same time, been elevating and celebrating the activity and its practitioners. There are sculptures, reliefs and drawings of scribes in ancient Egypt, Mesopotamia and China, each of which accorded scribes with a special revered status. The Egyptians referred to their hieroglyphs as 'writing of divine words' since the very art itself was handed down by the great god Thoth. So powerful was writing that it was said that whoever drank the inky drink made of a washed-down scroll would unravel its secrets.

Two basic features of being human coalesce in the practice of writing: language and the capacity to draw. As animals, as primates, hominids would have been communicating many millions of years, but current research suggests that the advent of symbolic language can be traced to roughly 300,000 years ago. It would take another

roughly 150,000 years before intentional markings on solid form gained currency. These would have been incisions on animal bones, cave paintings or stone markings (petroglyphs). However, the leap of imagination enabling thought and speech to be conveyed by means of a methodic and organized system of graphic signs is, in evolutionary terms, very recent and extremely rare. The earliest writing systems date to about five thousand years ago and occurred independently of one another only three times (or maybe fewer, maybe the haze of history has obscured how the idea of writing migrated from one people to another).

One of the earliest forms of writing: a Sumerian cuneiform tablet, c. 3100–2900 BCE

There is another way of looking at it: speech is so natural that today there are extant about 6,000 languages; if you add to this number the extinct or defunct languages we could say that there are or have been some 30,000 different languages. Language in spoken form is abundant, transporting thought and ideas between individuals and peoples like the flowing waters of a great river system constantly carving itself many side streams that gradually become rivers in their own right. Writing, on the other hand, as the poet and linguist Robert Bringhurst observed, is language in solid form; it is invented, organized, systematized and totally reliant on political and social institutions. Solidity also implies technology and every writing system is a token of its first and most-current implements, be they clay and reed, pen and ink or keyboard and computer.

All writing begins with pictures, but no writing system remains thus. First the pictures are abstracted and codified, then, crucially, graphic marks that represent the sound of words are incorporated. Every mature writing system in use today employs, in different degrees, these two basic

elements: abstracted pictures (pictographs) and phonetic marks (phonographs). Some scripts, such as Chinese or Japanese, are, at varying degrees, pictorial, while others, such as Latin or Arabic, are predominantly phonetic.

To better understand this it is worth casting a cursory glance at how scripts evolve. Pictographic writing systems use simplified pictures and abstracted graphic marks to communicate linguistic content. The Egyptian hieroglyph ☉ for sun is one example, the Chinese character 女 for woman is another; so is the current popular ideogram ♡ for 'love' and every currency sign such as £, € or $, or, most noticeably, numerals (1, 2, 3, etc.) and most other mathematical signs. Writing begins when graphic marks attain a degree of standardization that makes their linguistic content mutually understood beyond the confines of space and time and rich enough to convey meaningful sentences. To achieve this, the signs and the way they are read need expansion and enhancement. There are many ways to do this. For example, if one were speaking in English and using ☉ to represent the heavenly body 'sun', one could expand its usage so that it also stands for 'son', i.e. male offspring. However, to avoid confusion there would need

Hieratic papyrus fragment, c. 1183 BCE

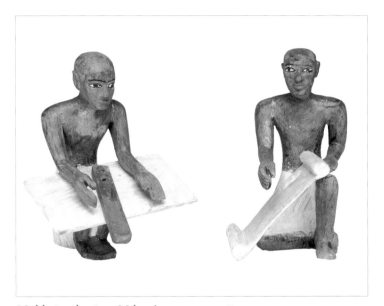

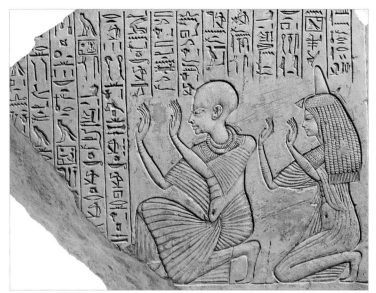

Model of scribes from Meketre's granary, c. 1981–1975 BCE

The priest Userhat and his wife depicted on a votive stela, c. 1353–1323 BCE

to be another sign (a determinative) indicating when it is to be read as a picture (a logogram) and when as a sound (a phonogram). Another possible expansion would be to introduce signs that modify a given picture by joining a sound to it. For example, the combination 🐝 🗁 could stand for 'belief'. We could decide that henceforth, 🐝 will always express the sound 'bee'. And should we want to refer to the insect itself in writing – simply let common sense prevail (though 'simply' is never quite so simple).

This is indeed how writing systems such as those of ancient Mesopotamia and Egypt worked for thousands of years, and Chinese and Japanese (to cite just two examples) still do today. Since these writing systems employ pictures augmented by sound they are called mixed writing systems. It is evident that these systems are *complex* and that they are *copious*. A potential reader-writer needs to be well-versed in the system's conventions and needs to recognize a very large number of signs. In Chinese there are some 50,000 characters, though admittedly to be considered educated, acquaintance with 8,000 will suffice. Still, to work as a system of communication, it is not enough to rely on simple intuition, it needs to be standardized. The lone Chinese character 女 stands for 'woman', reduplicated 奻 it does not mean 'two women', but 'argument', and repeated three times within one character, 姦, it means 'adultery'. This

might seem quite arbitrary, but this supposed arbitrariness is in the very nature of writing systems (equally, it might convey certain cultural conventions worth pondering over). Clearly, to function as a means of communication Chinese needs to be acquired by rote and retained by memory, though, admittedly, a dictionary might come in handy.

In the second millennium BCE there were, in different parts of the world, several fully-formed and adequately functioning writing systems quite independent of each other and exhibiting varying degrees of complexity and copiousness. Then, sometime in the middle of the millennium, something exceptional happened. A group of early Semitic people familiar with Egyptian hieroglyphs radically transformed writing in the process of adapting it to their language. They latched on to an inherent feature of the system – the presence of phonetic glyphs (as the 🐝 above) – and completely liberated writing from pictorial form, making it thereby not only phonetic, but, crucially, exclusively phonetic. The moment writing represented sound, complexity was exchanged for simplicity and copiousness for economy. This revolution gave rise to a phonetic script composed of a finite number of consonantal glyphs, roughly twenty in number, that could be acquired and read with relative ease, and whose phonetic nature made them readily adaptable to any language whatsoever. This

script, the alphabet, is the basis or model for the ubiquitous writing system that is used throughout the world today in its many different guises: Latin, Greek, Cyrillic, Arabic, Hebrew, Brahmi (and all the Indic scripts derived from it), Korean – to name but a few.

Proto-Sinaitic

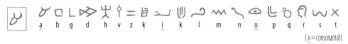
a b g d h v z k ı k l m n o p q r s t
(χ = consonantal)

IPA – International Phonetic Assocation (in British English)

ɑː tuː biː, ɔː nɒt tuː biː, ðæt ɪz ðə ˈkwɛstʃən: ˈwɛðə tɪz ˈnəʊblər ɪn ðə maɪnd tuː ˈsʌfə . ðə slɪŋz ænd ˈærəʊz

Latin (in Turkish)

A Küçük bir çocuğun yokuş aşağı koşması gibi seni düşünmek … Biraz heyecan, biraz da düşecekmiş korkusu.

Greek

A μῆνιν ἄειδε θεὰ Πηληϊάδεω Ἀχιλῆος οὐλομένην, ἣ μυρί᾽ Ἀχαιοῖς ἄλγε᾽ ἔθηκε,

Cyrillic (in Russian)

A Лорем ипсум долор сит амет, Пер цлита поссит ех, ат мунере фабулас петентиум

Devanagari (in Sanskrit)

अ नारायणं नमस्कृत्य नरं चैव नरोत्तमम ॥ देवीं सरस्वतीं चैव ततो जयम उदीरयेत ॥ लोमहर्षणपुत्र उग्रश्रवाः सूतः पौराणिको

Hebrew (read right to left)

א בראשית, ברא אלוהים, את השמיים, ואת הארץ, והארץ הייתה תוהו ובוהו, וחושך על-פני תהום; ורוח אלוהים,

Arabic (read right to left)

ا قفا نبك من ذكرى حبيب ومنزل بسقط اللِّوى بينَ الدَّخول فَحَوْمَلِ فتوضح فالمقراة لم يَعفُ رسمها لِما نَسَجَتْها من جَنُوب وَشَمْأَلِ

Hangul (for Korean)

ㅏ 청산리 벽계수야 수 이 감을 자랑 마라 / 일도창해 하면 돌아오기 어려우니 / 명월이 만공산하니 쉬어간들 어떠리

Scripts directly or indirectly descended from, or indebted to, the original proto-Sinaitic alphabet, with the rough equivalents of the aleph *highlighted*

The alphabet was an idea that caught on like wildfire, spreading in every direction. In the Mediterranean basin, its rapid dissemination began with the sea-faring Phoenicians. Before too long the Greeks acquired it, redrawing and adapting it to suit the needs of their language though retaining the underlying principle. It was eventually copied and modified by the Romans (via the Etruscans), who passed it on to all of Europe. Even though the Romans only had 22 letters and the most rudimentary punctuation, the core of the Latin alphabet has been relatively stable, even

in the face of persistent changes in the way the languages it embodies are spoken. Over the years, it has also proven to be extremely adaptive, allowing itself to be used by some 140 languages throughout the world. Curiously, the characteristic feature of the English version of the Latin alphabet is its resistance to embellishment and change. While most European and non-European languages grace the letters with instructive diacritics (e.g. à, î, ç, ñ, ü, ž) and enrich the core set with distinct forms (e.g. ß, ð, Þ, Å, ø, Ł), English is minimalist, preferring to go naked and unadorned. Since this book celebrates this version of the Latin alphabet it will concentrate on the core 26 letters and two punctuation marks to boot.

ONE PARTICULAR aspect of the alphabet tends to be overlooked when it is discussed more soberly: the conspicuous attraction between letterforms and the human body. There is good reason to overlook this aspect, even though it is, and has been, an occasion to indulge in some visual *divertimenti*. The reason is that letterforms have been completely abstracted from the objects from which they were derived. Eric Gill, one of the most accomplished typographers of the 20th century, famously said, 'Letters are things, not pictures of things.' At the same time, to some extent, our bodies are what we are, not only enabling us to perceive the world but also informing us about it. Thus every chance to discover the bodily origins of familiar shapes is a just cause for celebration. This can work in both directions: in the joy of recognizing the body in our alphabet and also in reading the body back into it. Both directions are worth looking at in greater detail as a prelim to this book's splendrous alphabet.

It is possible to draw a direct line between five extant letters and the body part with which they are associated. So much so that one is entitled to say that every time you write the letter P you are unwittingly evoking a reference to the mouth; that every K you encounter can be traced back to a primaeval picture of the palm of the hand; that

an O is not just an abstracted circle, it is a simplification of an already reductive drawing of the eye; that the letter I, erect and proud, bears testimony to the hand; and, lastly, that the regal R was derived in a roundabout way from a crude depiction of the head.

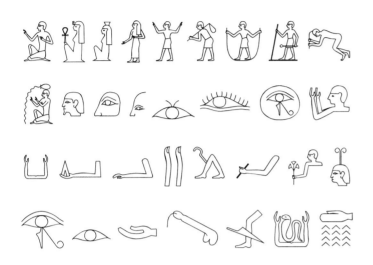

Examples of Egyptian hieroglyphs that employ depictions of the human body

We can begin by recalling the prominent pictorial source of the alphabet, the numerous Egyptian hiero-glyphs that depict the body and a plethora of body parts: eye, forearm, foot, mouth, hand, etc. Take for example a hieroglyph showing the hand (⊑). Even though it has no phonetic relation to our alphabet, as a graphic mark it could be readily appropriated and transmuted. And indeed in Proto-Sinaitic, one of earliest forms of our alphabet, we find the sign ✔ which was referred to as *kaf*, the word for palm of the hand (corresponding to the letter כ in Hebrew). In a later Semitic script it appears as ⅄. The Phoenicians redrew this as ⅄, which the Greeks wrote as K/κ, calling it *kappa* and thus passing it on to the Etruscans who kept it intact. The Romans had little use for this letter, though they did not discard it. It became a fully-fledged member of European alphabets only in the 12th century when writing the vernacular made it useful.

Next, consider the origins of our letter O. In Sinaitic scripts there is 👁, very much a simplified drawing of the eye and quite similar to the hieroglyphic representation of the eye. The Phoenicians simplified this to ◯. The Greeks retained this basic shape, hence the *omikron* is O/o. The Etruscans kept it intact and the Romans followed suit.

Much more complicated is the case of the R and P. In Proto-Sinaitic we find variants of the shape ☌, which is a depiction of a head. In the later North Semitic it appears more stylized as ⅄, referred to as something like *rash*. The early Phoenicians did not alter the shape much and passed it on the Greeks, who wrote (and write) it as P/ρ, calling it *rho*. *Rho* is much like the Hebrew word for head — *rosh* — and the name of the corresponding letter *re'sh*, written today thus: ר. In our post-industrial age with its mass commu-nication and mechanized reproduction where literacy is prevalent, it is all too easy to forget that attaining rela-tive stability and continuity of letterforms was quite an achievement. In the first millennium BCE only a small part of the population was literate and scribes were few. Each piece of writing was unique: to copy or to reproduce was to rewrite. All writing was handwriting and thus inevi-tably prone to change and local variance. And so, it is not surprising to find that while in early Latin *rho* still appears as ⅄, later on it grew a tail ⅄ to become R, probably in order to distinguish it from competing forms such as D, which was written thus: ◁ (which ended up in Greek as *delta*, Δ). The similar-looking Roman letter P is a direct descendant of the Phoenician ⁊, which is the Semitic *peh* 'mouth' (current in Hebrew and represented by the letter פ). In Greek, this letter ended up as Π/π (*pi*), via the earlier form ⌐. The Romans, via the Etruscans, rounded it off and thus, at the end of a circuitous journey, we get the Latin P. We should note that the direction in which the letter is facing was at that stage somewhat arbitrary since the direction of writing was also evolving. These last few sentences were (perhaps in keeping with the subject matter) a bit of a mouthful, so let us leave these rumina-tions on the body-in-the-alphabet and ponder on proper letter physique; namely, when human form embodies the letters of the alphabet.

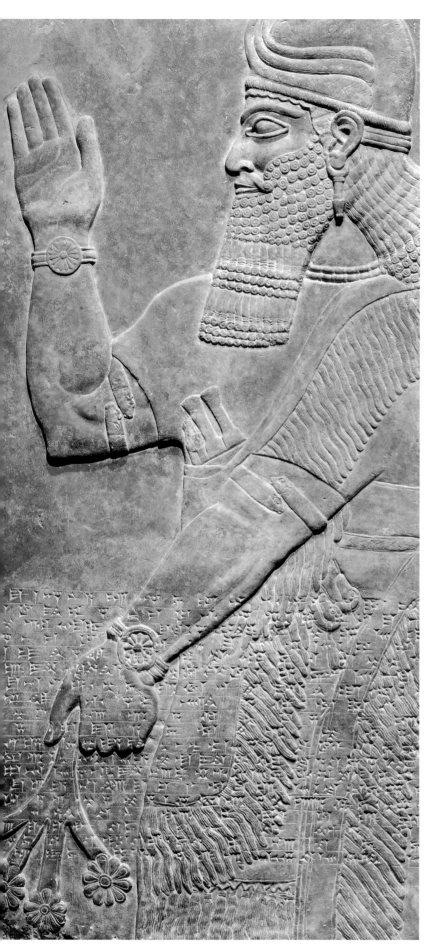

Neo-Assyrian relief panel of winged supernatural figure from the Northwest Palace at Nimrud, c. 883–859 BCE

PICTURES PLAYED A CRUCIAL ROLE in the development of writing and then in the shaping of the letters of the alphabet. Once writing stood on its own two feet, it began to have a life of its own and words began to flow endlessly, on papyrus, on scrolls, on tablets and on every other possible medium. Interestingly, right from the very beginning, pictures remained happily coupled with writing, each finding room for the other on their chosen medium. This was true throughout antiquity and in ensuing book culture. Images were never superfluous decoration, they played an important role in communicating content and subject matter. In a culture such as ours, where the prevalence of literacy is high, it is all too easy to forget this and to assume the primacy of the written word when image and text appear in conjunction.

One could say that the history of the book in the West commences around the beginning of the 4th century CE, when the codex began to supersede the scroll as the predominant form of written material. The codex is the book as we know it. It is made of pages gathered into a block in which both sides of the sheets are utilized and bound on one side (the book you are holding is a codex). By the 6th century, the codex was the predominant book form, and until recently, with the introduction of the e-book, it has been unchallenged. It is easy to see why the codex is so appealing: it's easier to handle than the scroll, more economical to produce (since both sides are used) and, crucially, it allows easy random access while still respecting sequentiality; lastly, it never runs out of battery. Even though the codex had clear advantages over the scroll or tablet, the early codices were still complicated and expensive undertakings. Typically, in the early Middle Ages books would be produced in monasteries by groups of monks, each taking on different aspects of the production: copying, binding and illuminating, the latter being one expression of the importance and sanctity of the book. In many manuscripts elaborate ornamental initials, called 'versals', were drawn or painted in order to indicate chapter openings and other important headings.

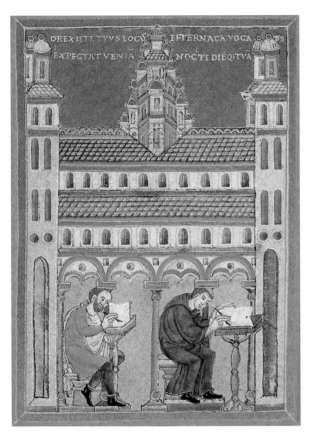

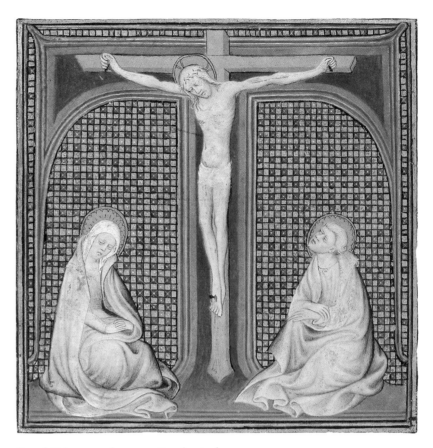

In the scriptorium: layperson and monk jointly making books in Echternach Abbey, c. 1020

Initial T from a 15th-century French missal

Interestingly for our discussion, the illuminated capitals of these ancient manuscripts house all sorts of characters: weary simpletons, fiery angels, frightful demons, pious saints, mythological beasts – not to mention divinity itself. Not so curiously, from as early as the 14th century, we see illuminators being drawn deeper: instead of embellishing existing letters with people, they create letters from people. And so, sitting humbly at the periphery of book culture and graphic design, there is a continuous tradition of creating letters in the shape of human beings. Humble it may be, but these anthropomorphic letters are as distinctive as they are persistent. From the glory of Mediaeval illuminated manuscripts to the majesty of Renaissance books; from innumerable Baroque follies to Art Nouveau extravagances; from audacious Surrealist experimentation to digital mimesis – every artistic current has submitted its fair share of anthropomorphic letters, so much so that

we are entitled to ponder over their endurance and reflect on why, throughout the ages, artists and typographers have been so enamoured of this form.

I suggest that it all transpires under the aegis of communication. Our body, apart from anything else, is a natural organ of communication: we express ourselves non-verbally through facial expression, hand gestures, body posture, eye movement, touch and the way we occupy space. The fact that we are mostly clothed and frequently decorated means that we could extend body language to include costume and ornament. If expression through the body exemplifies natural communication, at the other end of the spectrum lies the completely artificial – yet totally effective – medium of writing, an invention designed to capture our fleeting words and freeze them for posterity. In anthropomorphic letters body language, the most natural form of human communication, imposes itself on complete

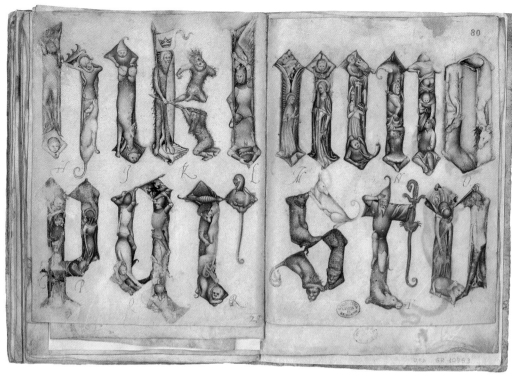

The Tudor Pattern Book
*c.*1525

Giovannino de' Grássi: page from Taccuino di disegni
Late 14th century

artificiality (writing). Anthropomorphic letters are simply an enterprising way of humanizing pure form, of making the geometry of letterform bristle with life. Creating such letters and deciphering them can be fun; it can also be instructive, or subversive, or simply a way to engage with the beauty of letters — but one should never forget that as a means of communication it is doomed to heroic failure since in the end, for writing to work efficiently, geometry must prevail.

The Kirkland alphabet occupies an interesting place in the practice of anthropomorphic letters. Three distinct elements conspire to make each letter. First, digital delights: groupings of inanimate objects selected and arranged by Françoise Kirkland and then reduplicated and reshaped digitally by William Thoren (see page 80); secondly, Erika Lemay's lively performance and, lastly, Douglas Kirkland's well-composed and curated studio shots of Erika's tenacious physicality. Each composition manages

to balance the core constituents of anthropomorphic lettering: artificiality on the one hand and naturalness on the other. The enactment is real, natural enough for someone to perform it — albeit someone with exceptional capabilities. And yet, notwithstanding these capabilities, the Kirkland alphabet also knows when to stop, when to respect the body's inherent limitations in order to make room for the higher calling of legibility. Every letter is instantly recognizable and fully functional.

There are two distinct attitudes to anthropomorphic letters. The first endeavours to create a whole alphabet whose constituent elements are letters composed of, or derived from, the human figure. Context and application, if considered, are of secondary concern; the challenge is to create an ensemble piece within a set of visual constraints. If it were a film, it would be, say, Robert Altman's *Nashville,* in which each member of the cast is a star in his or her own right, but the film itself outshines them all. The

RRRRʀ

Bubínky daly se na pochod
přes sedm mostů přes devět vod
Rʀʀ komedianti z Devětsilu
rozbili stánek na březích božského Nilu

38

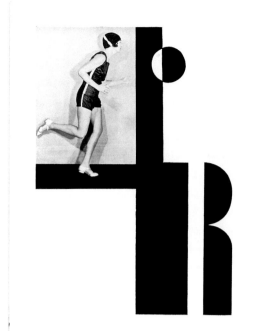

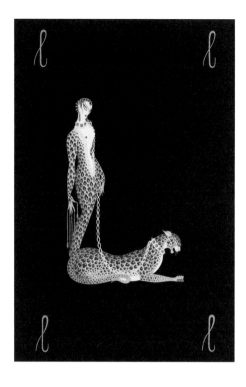

Karel Teige, 'RRRRʀ' from Abeceda
1926

Erté, from The Alphabet Suite
Begun 1927

1926 Czech modernist masterpiece *Abeceda* is a typographic example of this. Its origins are a collaboration between the poet Vítězslav Nezval, the dancer Milča Mayerová and the artist Karel Teige. The letters handed down to us are Teige's marvellous 'typofotos' from his book with Nezval, but at their time they were also a dance performance of a poem celebrating the alphabet that itself was linked to their constructivist manifesto for a new vision of Czech society. The second attitude concerns itself with the individual letter *in situ*. The letter is there in order to illuminate a page or embellish a word. To properly function it needs to be legible, not merely decorative. The letter here is conceived of as a type, a character (it is interesting to note the anthropomorphism of these terms). If this were a film, think of any character study that imbues presence on the whole, for example Charles Foster Kane in Orson Welles's *Citizen Kane*. Many of the anthropomorphic letters found in illuminated manuscripts and Renaissance and Baroque books exhibit this kind of commitment. They are there as characters (in all senses of the word) and relate to the text, to the page and to the book.

The Kirkland alphabet confidently straddles these two seemingly opposing commitments. It is clearly driven by a sense of wholeness and completeness characteristic of modern creations. As a group, the 26 letters of this alphabet are a modern dance troupe performing to Douglas's photographic choreography in a set designed by Françoise, with the music magically orchestrated by the playfulness of digital technology. On the other hand, when one examines each letter individually, one immediately notices the respect that this alphabet has for character, beautifully expressed in the almost classical portraits of its star Erika Lemay. These portraits, in typographic terms, represent legibility and textual functionality, so much so that I am tempted to say they have a near-Mediaeval quality. The versal adorning this introduction is a clear testimony to this.

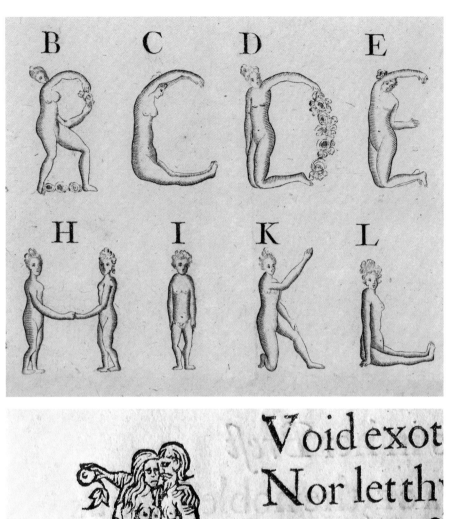

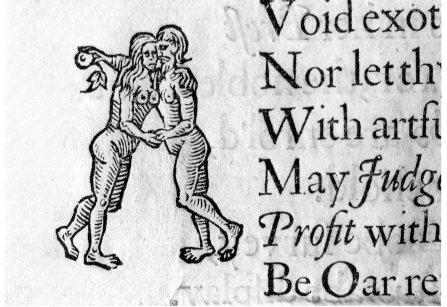

Above *Detail from Anon.,* Alphabeth de la Bourbonnoise, 1789

Below *Adam and Eve embracing, from Edward Benlowes's* Theophila

 with illustrations by Francis Barlow, 1652

A	B	C	D	E	F	G	H
He first finds the way, To form a great A.	By a bright thought, To a B he is brought.	He's forc'd to strain hard, Left the C should be marr'd.	Now a D he is found, With his Nose to the ground.	With the reft he'll agree, And affift them with E.	From the Head to the Feet, He's an F quite complete.	Look forward you'll fee, He's in form of a G.	With his Hands in the Air, An H does declare.

I	K	L	M	N	O	P	Q
He looks vaftly dry, While in form of an I.	Do but look and you'll fay, Here ftruts Comical K.	L fits him down eafy, And hopes for to pleafe ye.	Hah! Hah! here comes M, To accompany them.	Now N follows after, To excite you to laughter.	Any body may know, He's in form of an O.	Pray look at me, In the form of a P.	Any Shape I can take, So a Q here I make.

R	S	T	V	W	X	Y	Z
Here's an R to your view, Which I hope fatiffies you.	Here he's twifted & twin'd, To make S to your mind.	T next does exhibit, In form of a Gibbet.	V joins with the reft, In their humorous jeft.	It is ftrange but moft true, That I make W.	To pleafe every Sex, I am forming an X.	With his Arms full extended For Y is intended.	It will ftick in my Gizzard, If I can't make an Z.

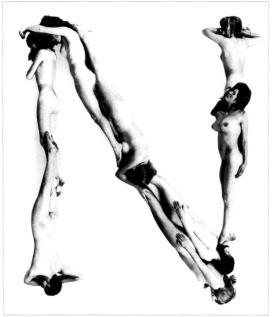

Above The Comical Hotch-Potch, or The Alphabet turn'd Posture-Master, 1782
Below, left E from *Anastasia Mastrakouli's* Naked Silhouette Alphabet, 2012
Below, right N from *Anthon Beeke's* Naked Ladies Alphabet, 1969 (*later renamed* Body Type)

Physical Poetry Alphabet

And so we begin this
adventure, in which
an affable aerialist
articulates the alphabet.

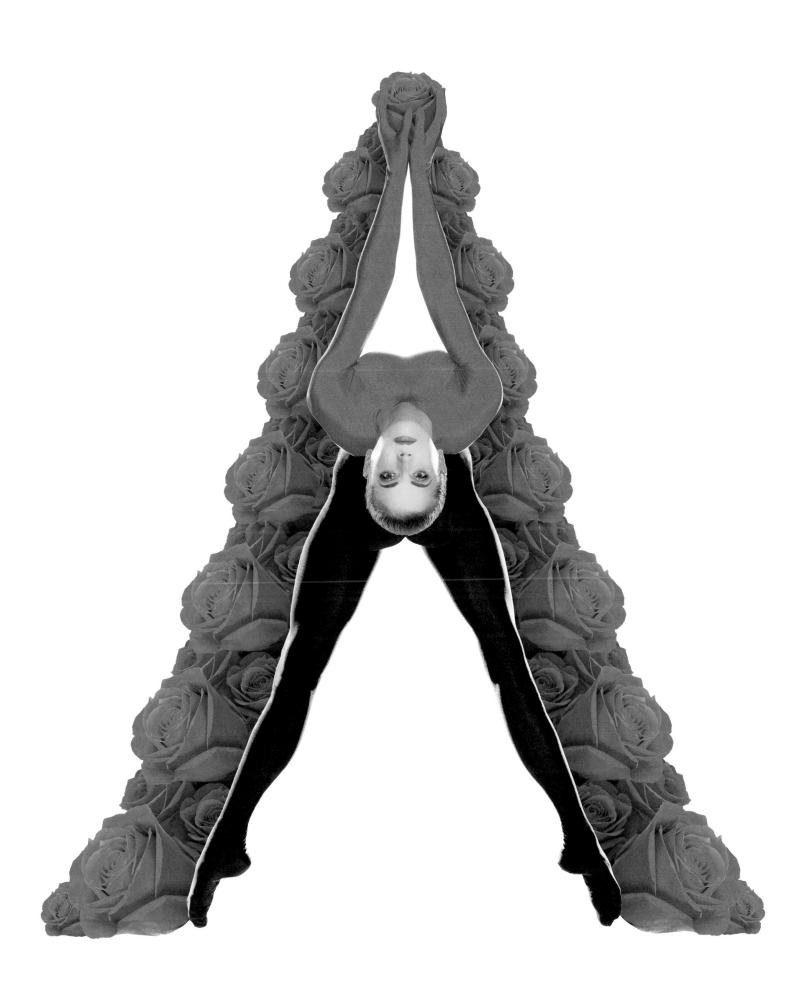

But before we begin this typographic burlesque, let us dwell a brief moment in order to

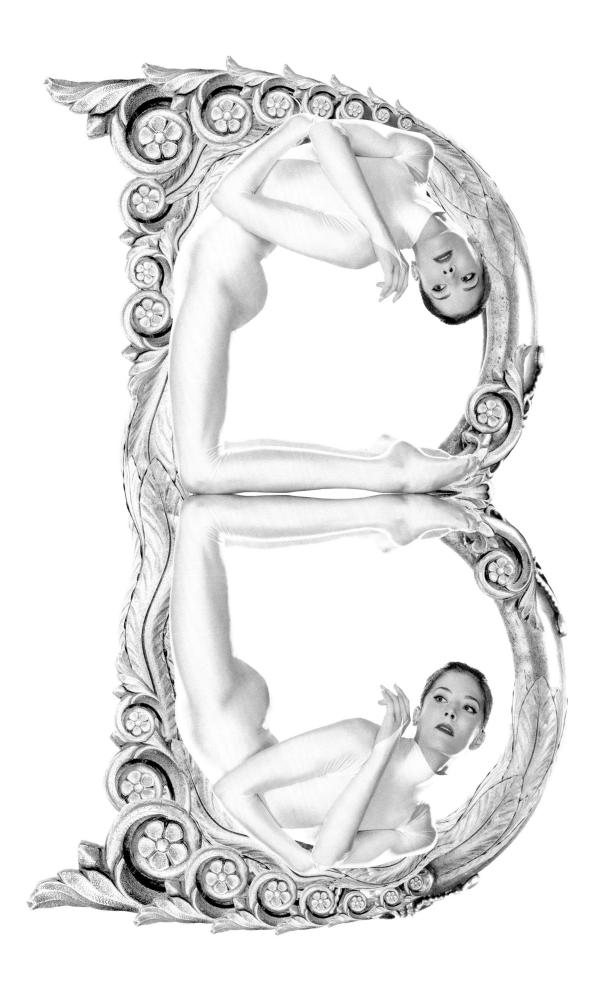

carefully contemplate a few of the challenges complicating this cheerful celebration:

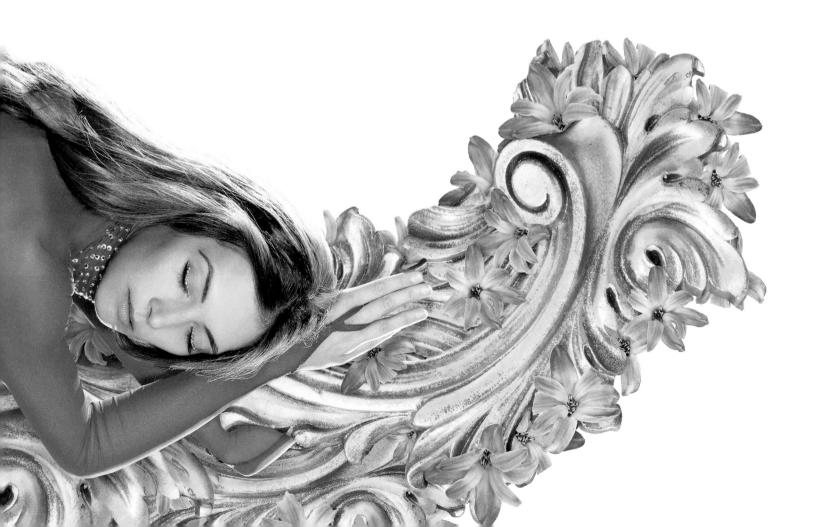

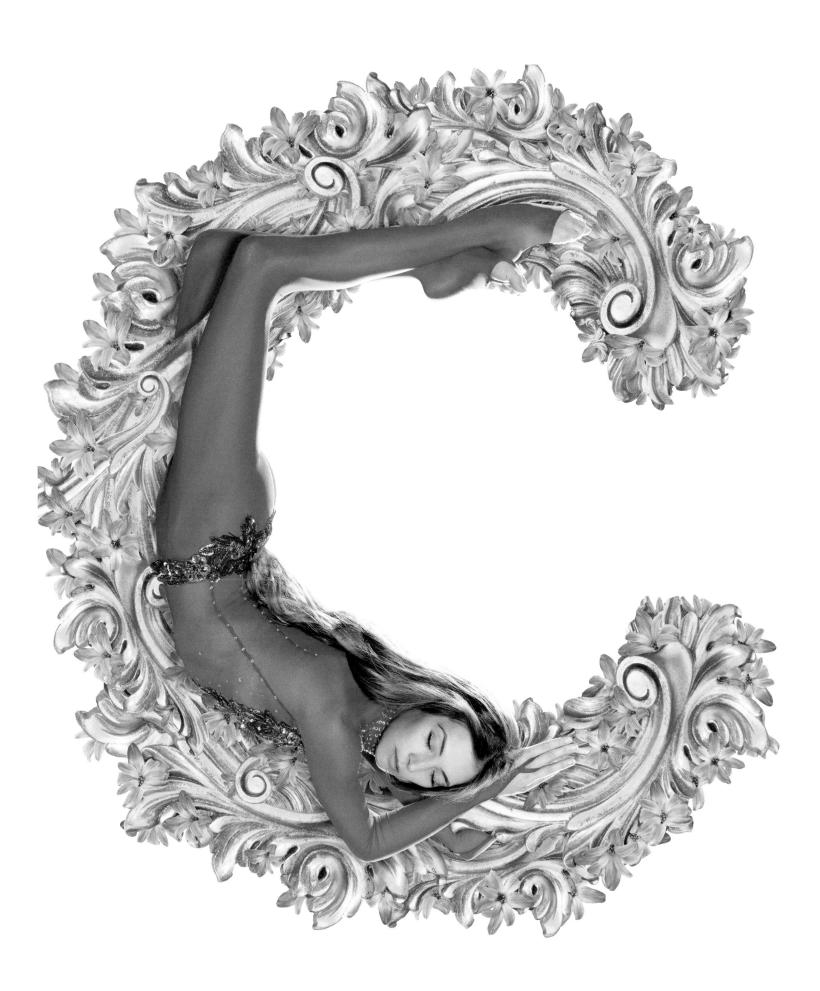

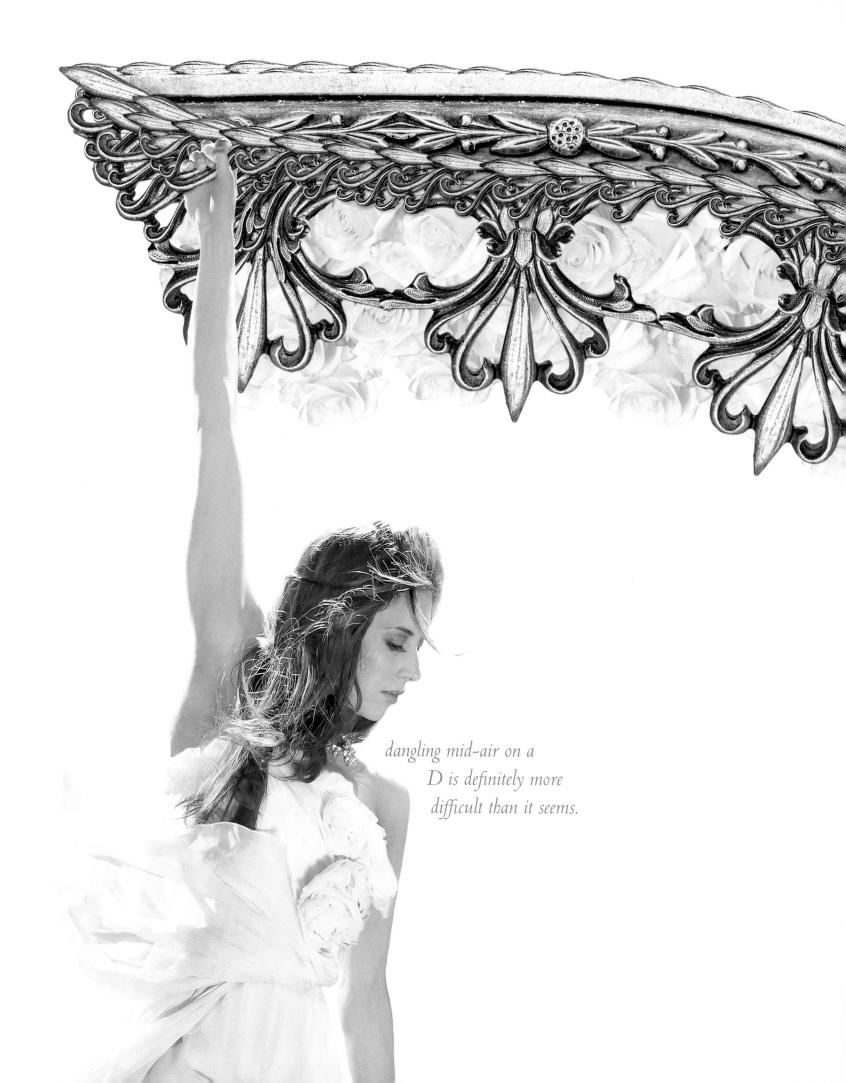

dangling mid-air on a
D is definitely more
difficult than it seems.

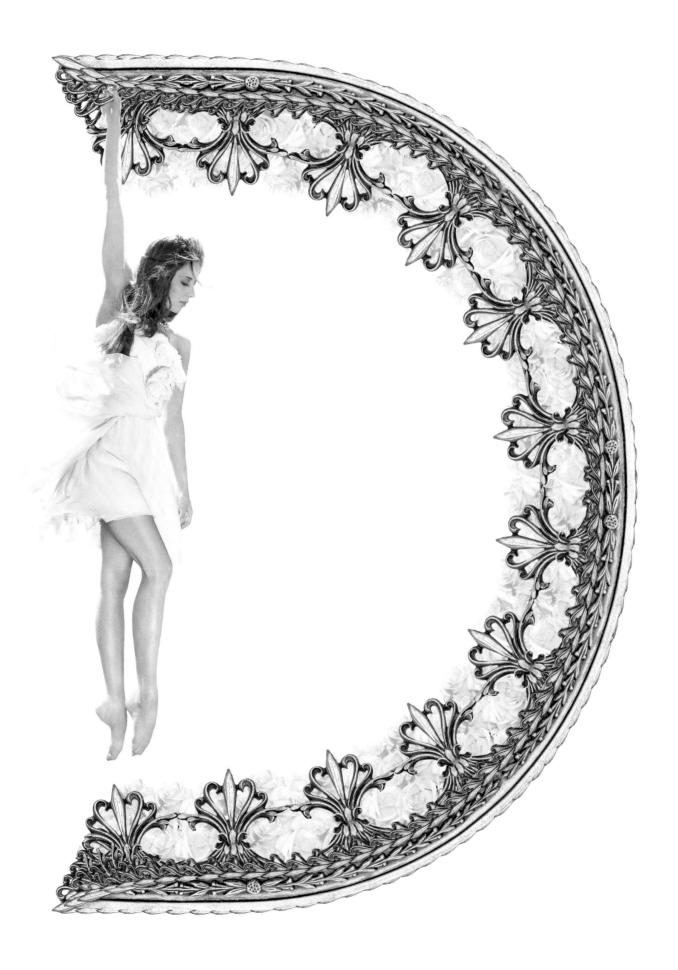

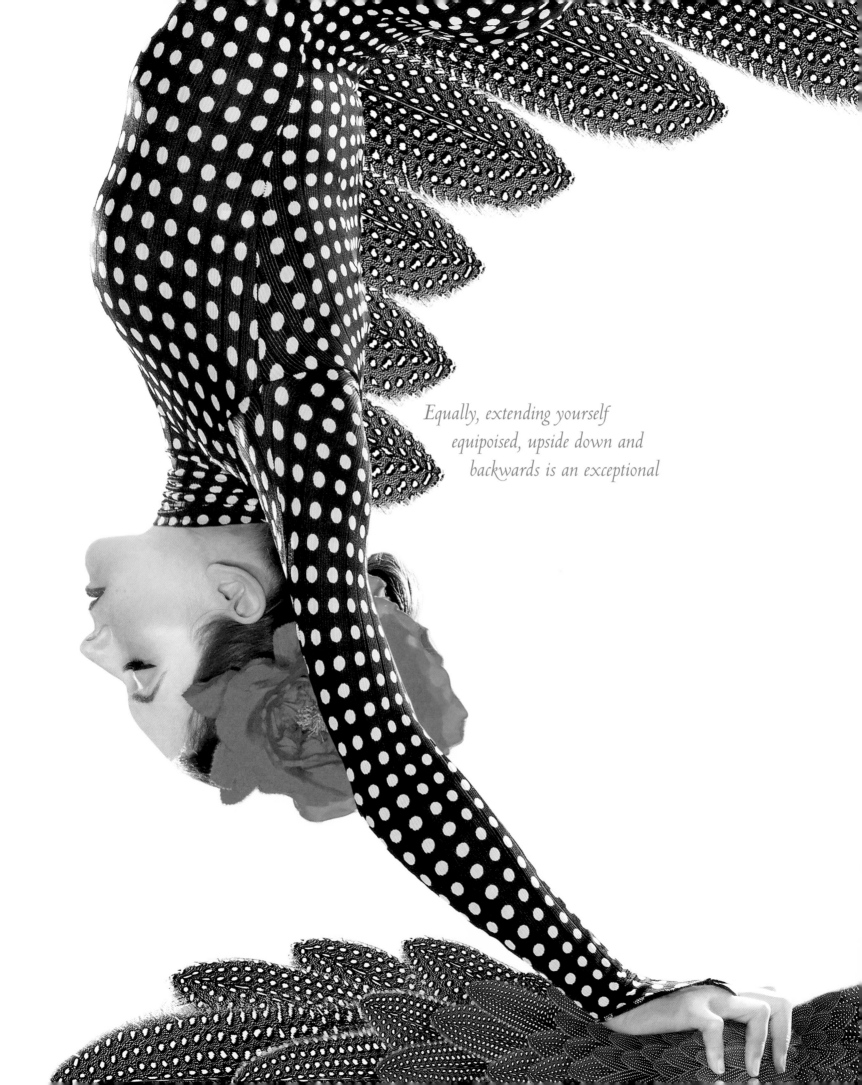

*Equally, extending yourself
equipoised, upside down and
backwards is an exceptional*

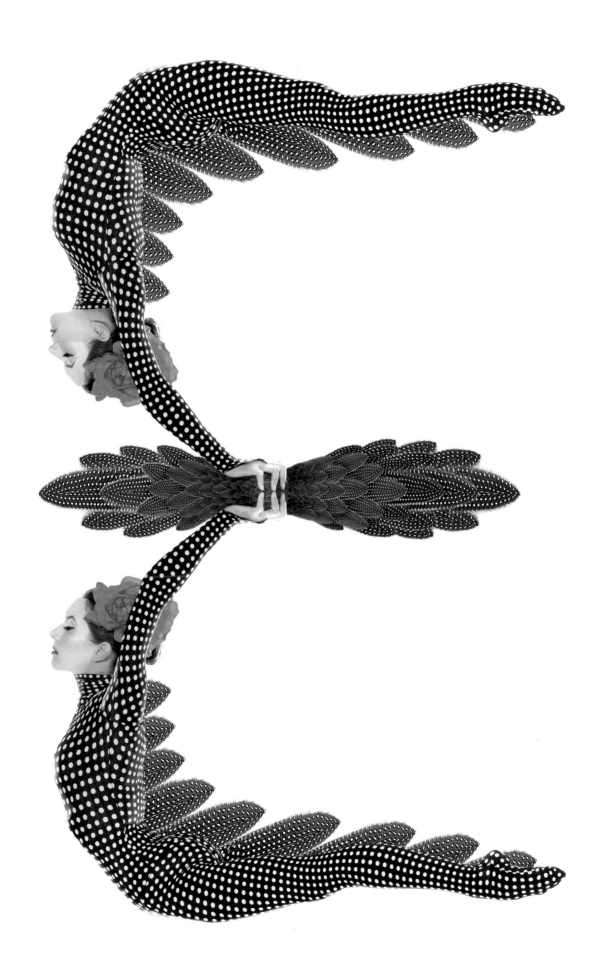

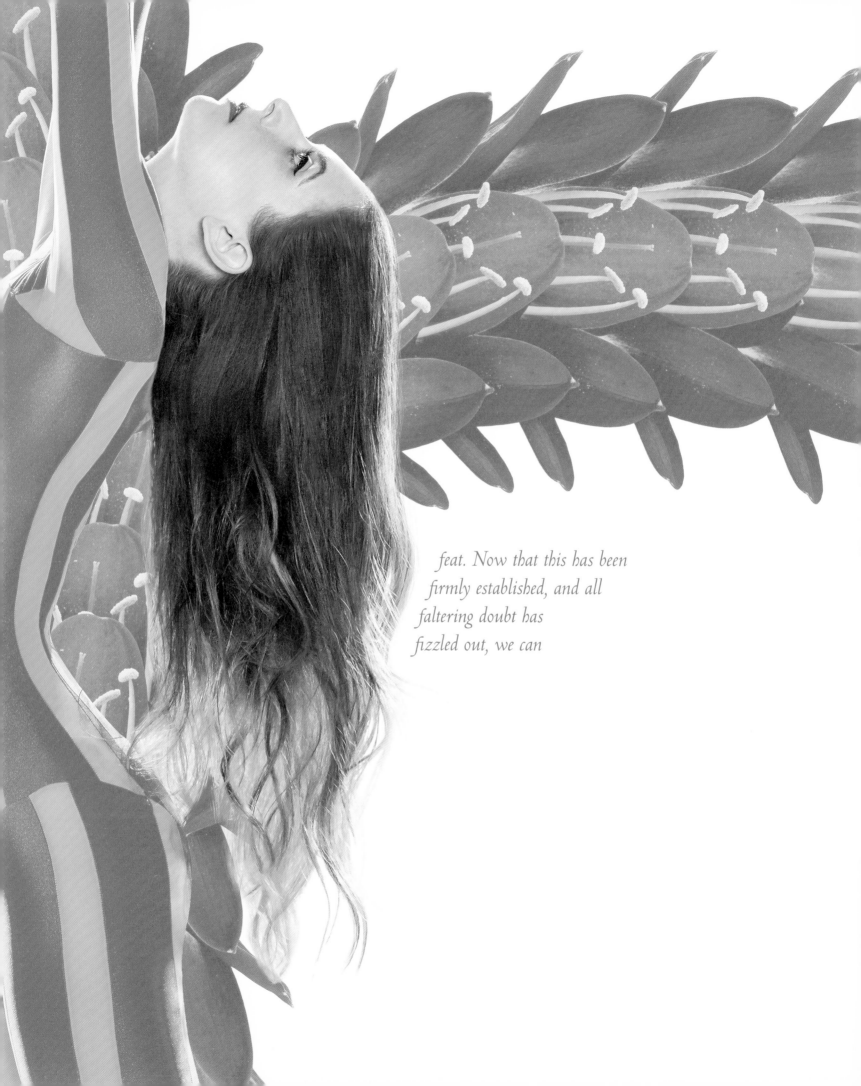

feat. Now that this has been
firmly established, and all
faltering doubt has
fizzled out, we can

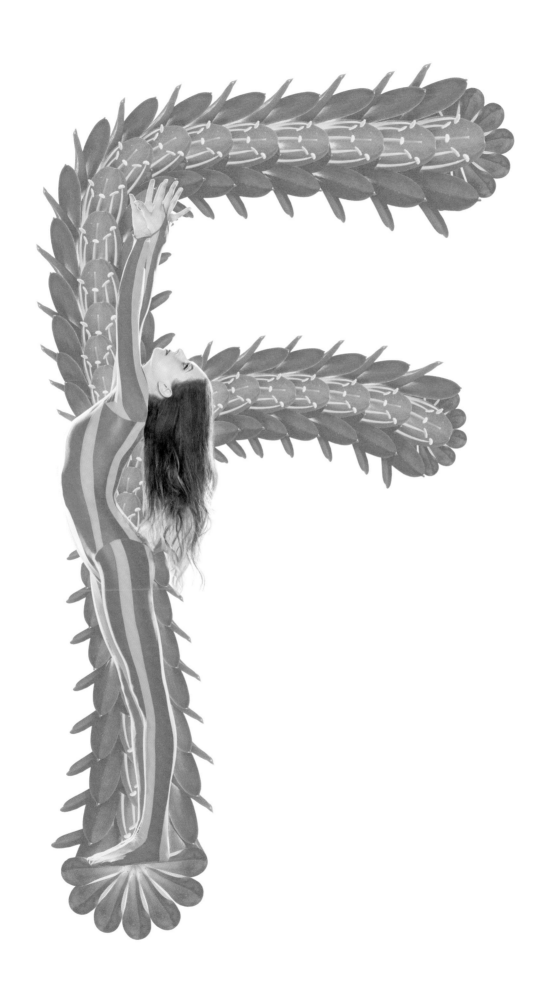

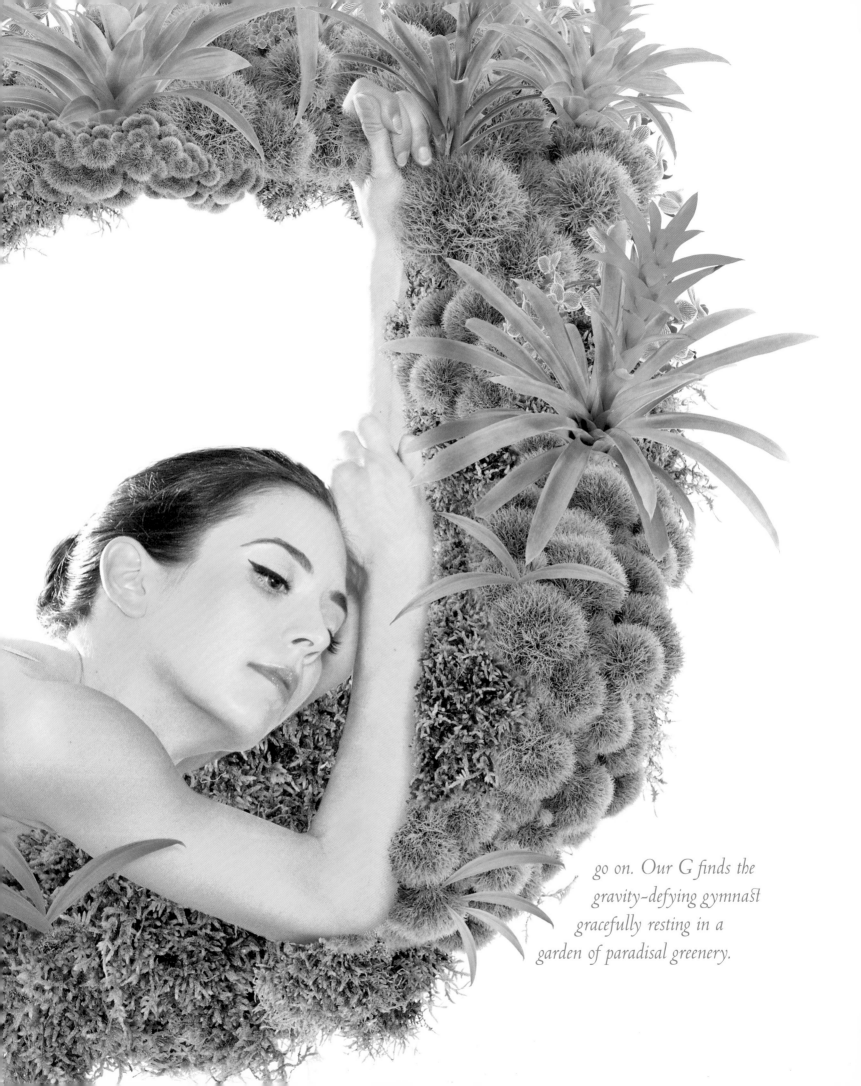

go on. Our G finds the
gravity-defying gymnast
gracefully resting in a
garden of paradisal greenery.

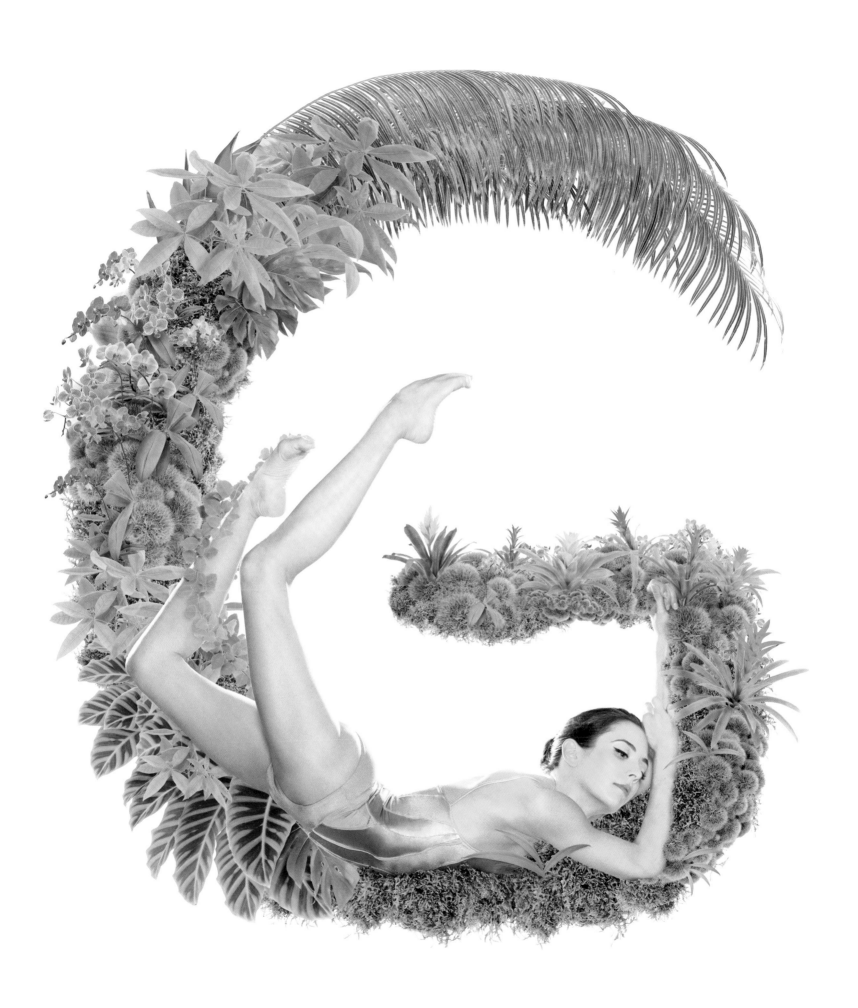

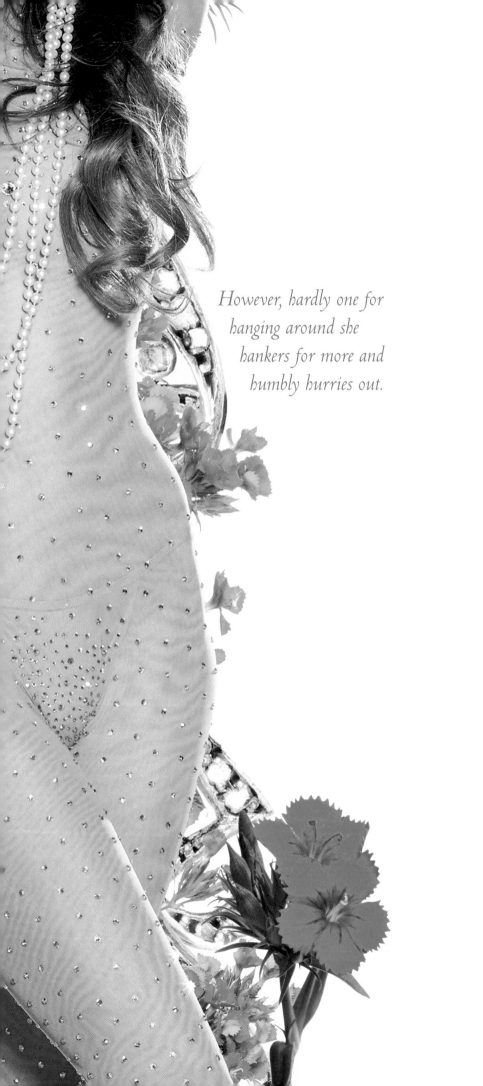

However, hardly one for
hanging around she
hankers for more and
humbly hurries out.

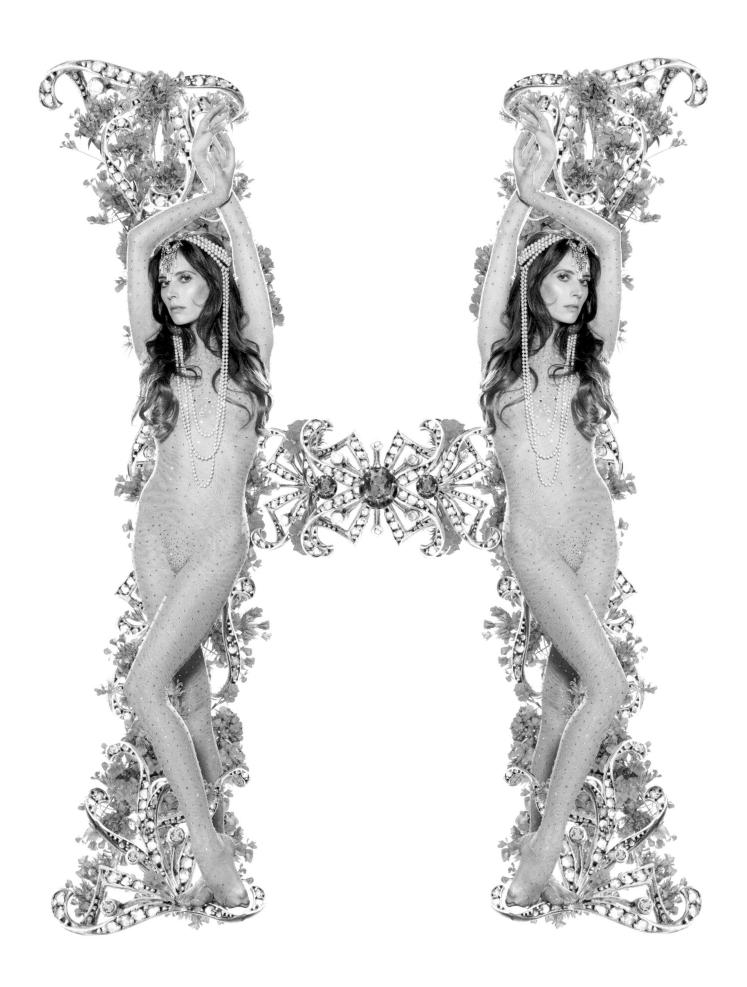

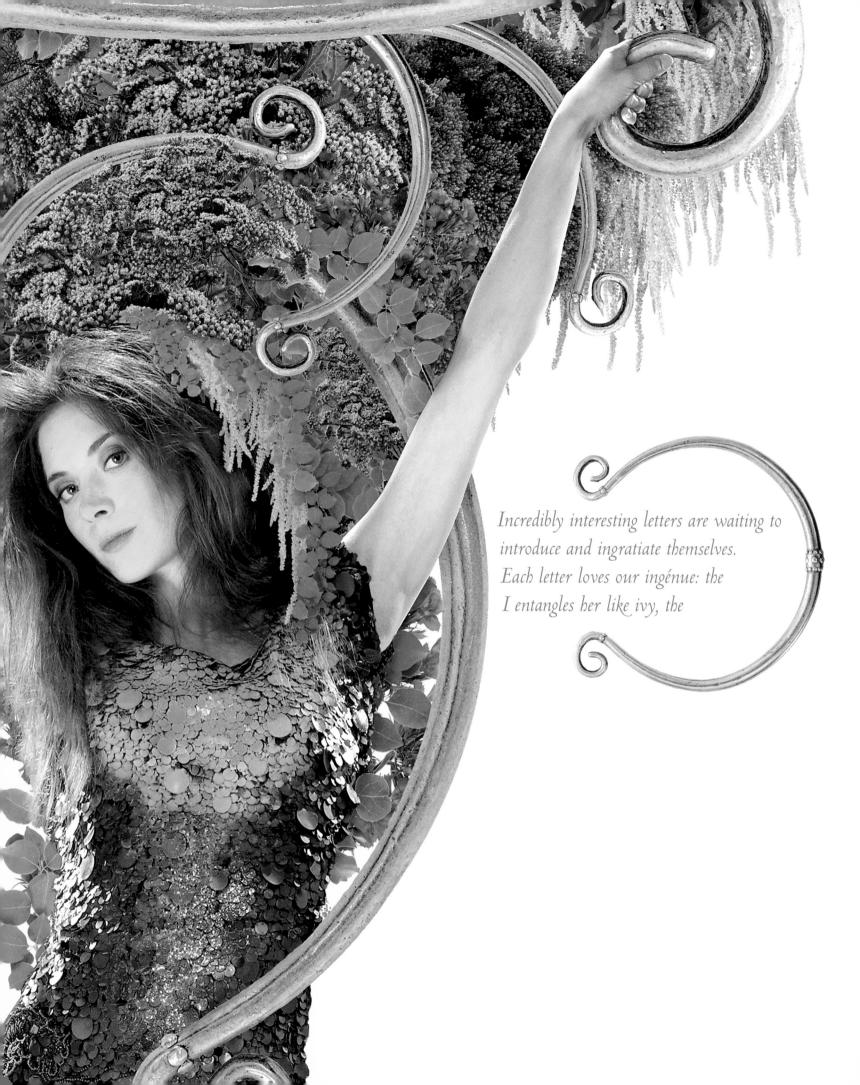

Incredibly interesting letters are waiting to
introduce and ingratiate themselves.
Each letter loves our ingénue: the
I entangles her like ivy, the

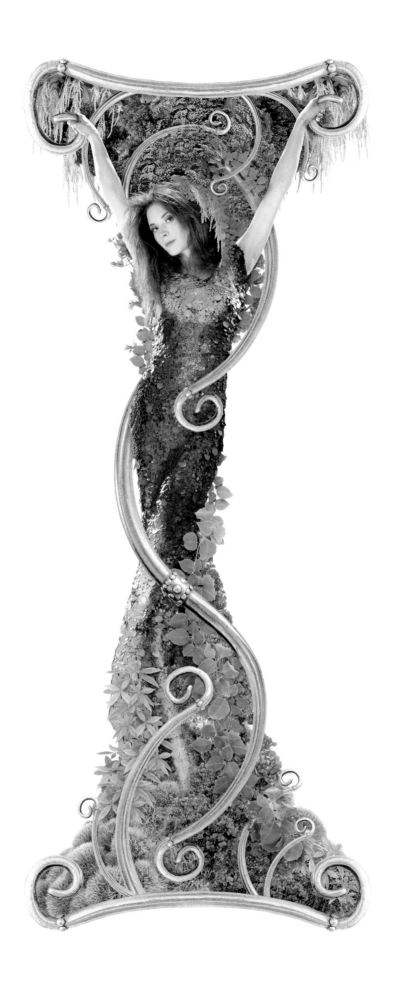

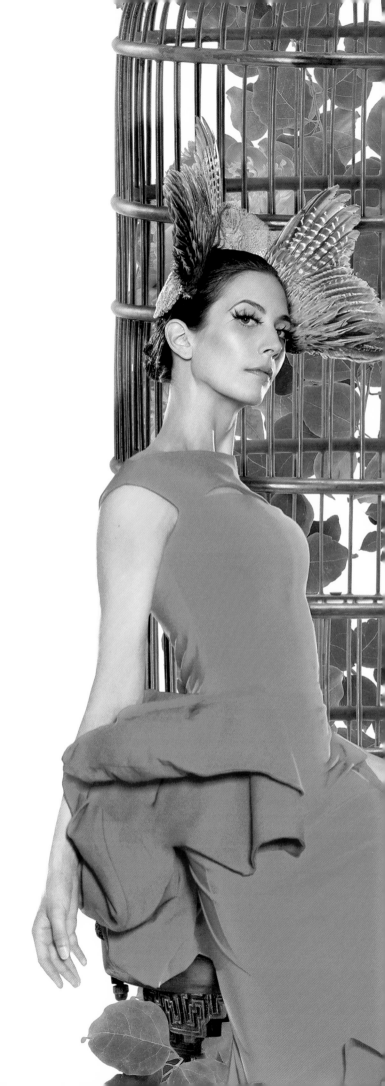

J jumps upon her,
jettisoning self-respect and,
somewhat jovially, tries to
jail her. Then,
just in time, like a

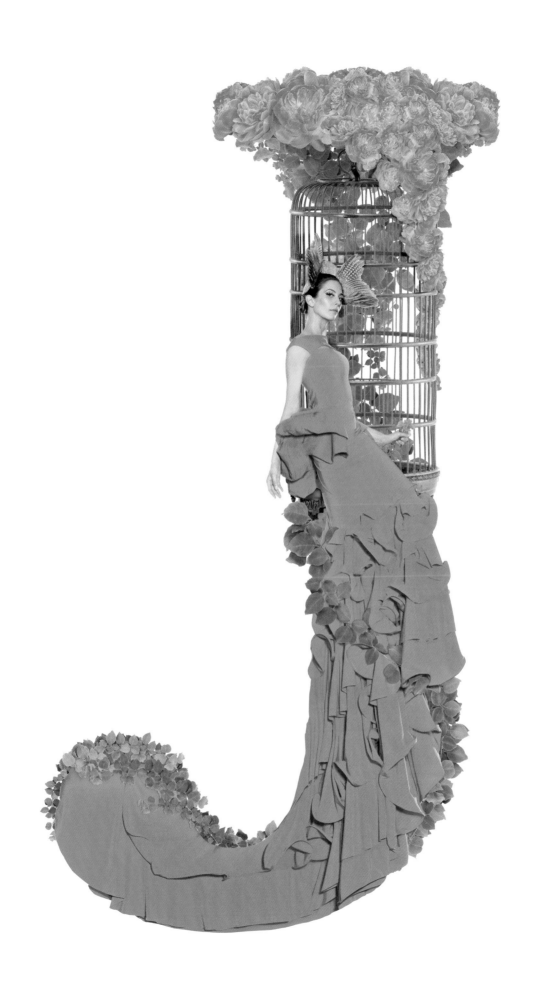

knight in shining armour, the kinky K kicks in, keeping the knuckling crowds at bay well knowing that

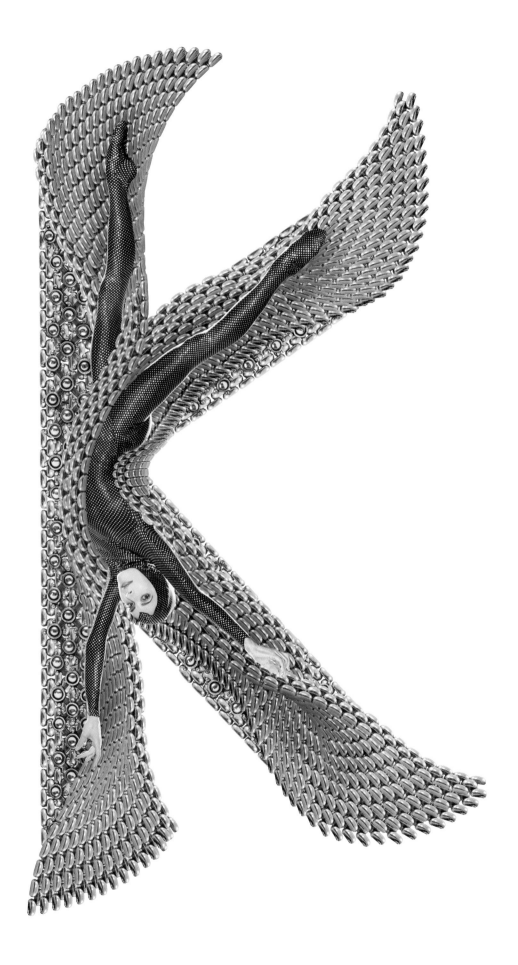

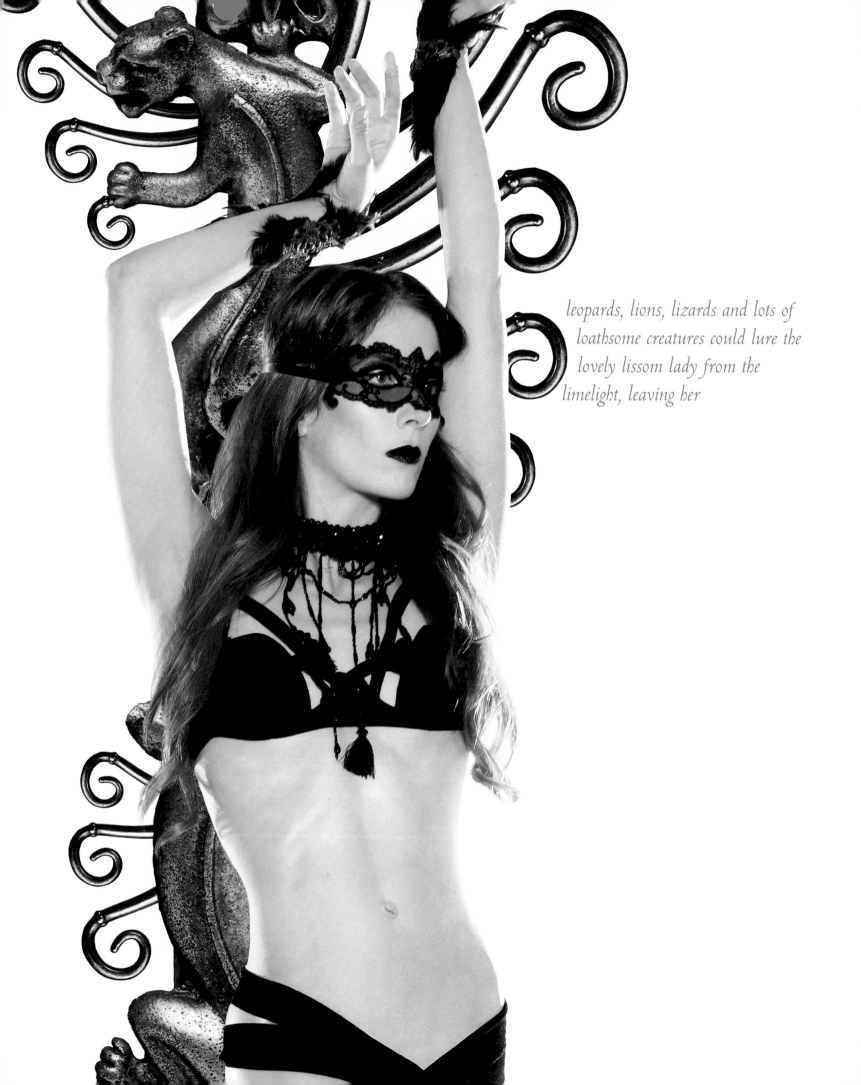

leopards, lions, lizards and lots of
loathsome creatures could lure the
lovely lissom lady from the
limelight, leaving her

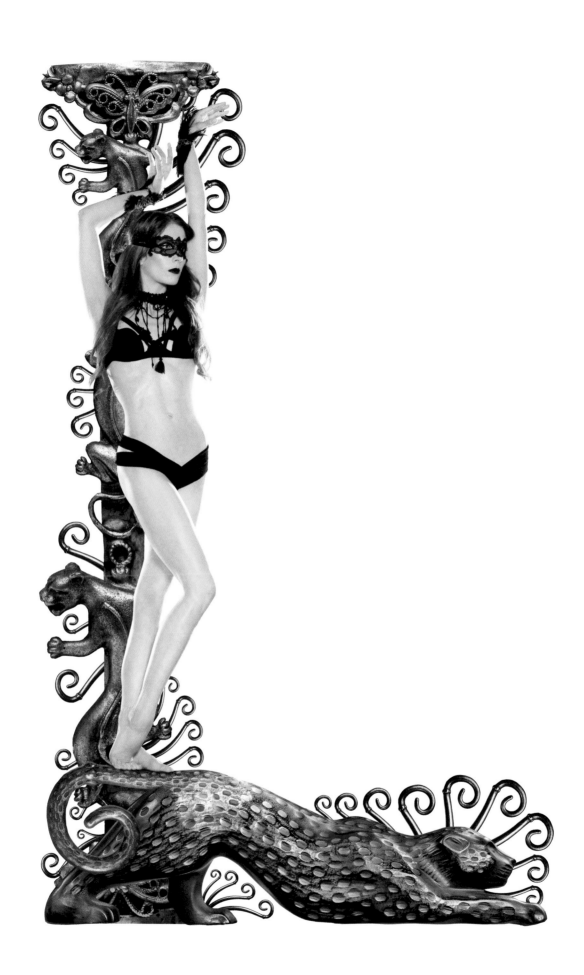

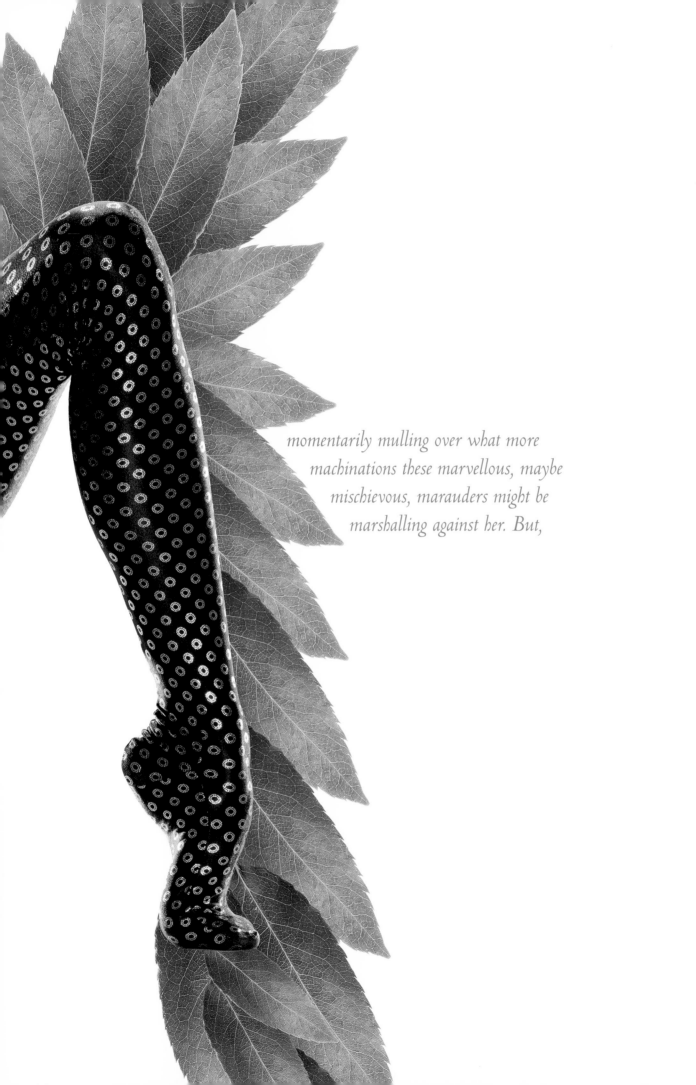

momentarily mulling over what more
machinations these marvellous, maybe
mischievous, marauders might be
marshalling against her. But,

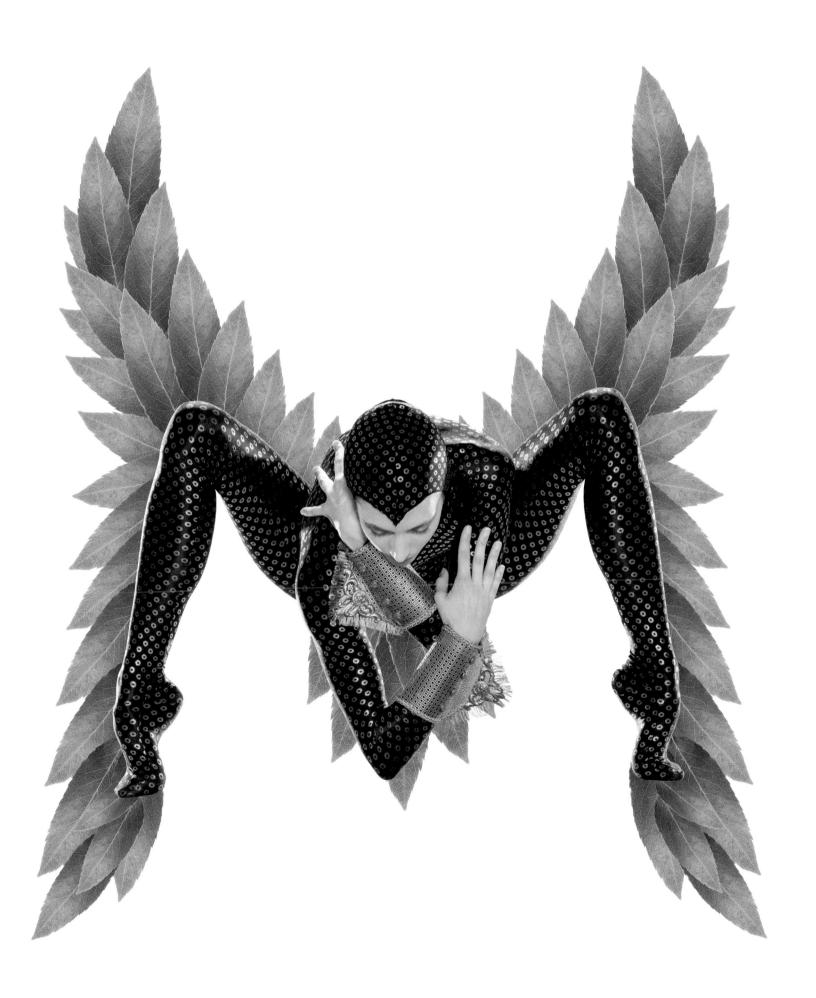

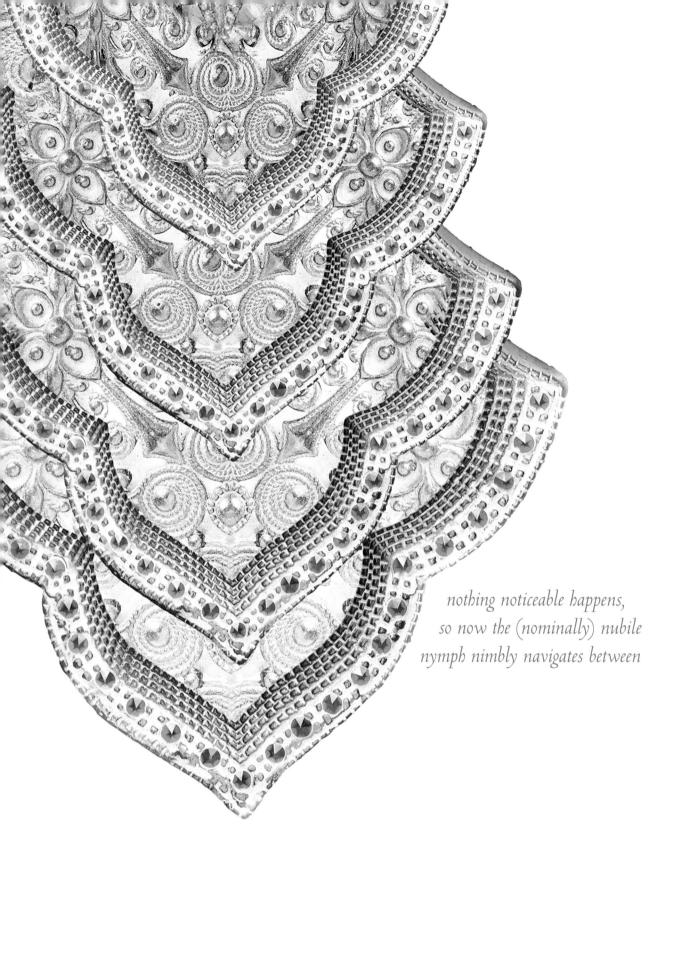

nothing noticeable happens,
so now the (nominally) nubile
nymph nimbly navigates between

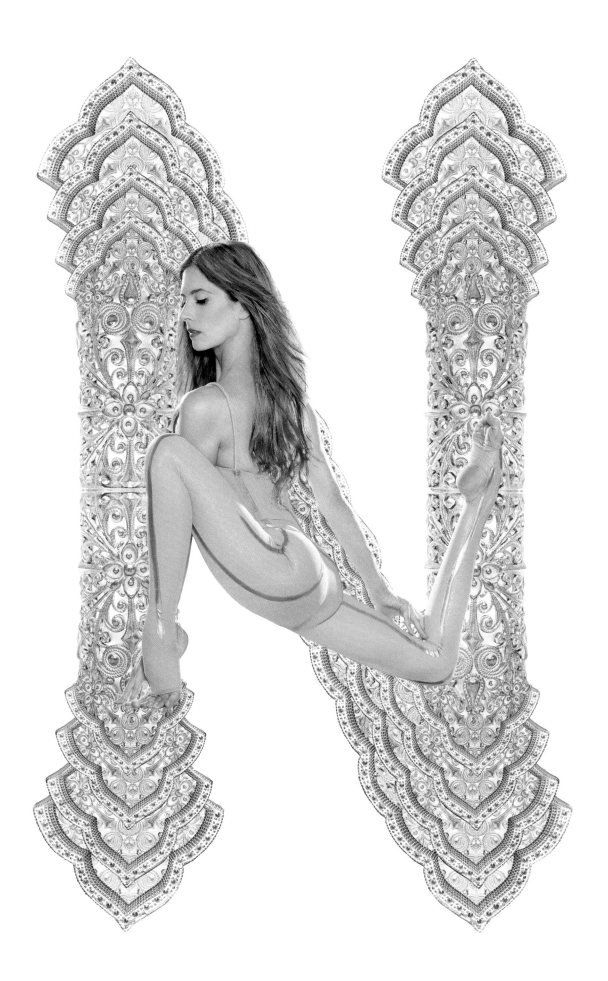

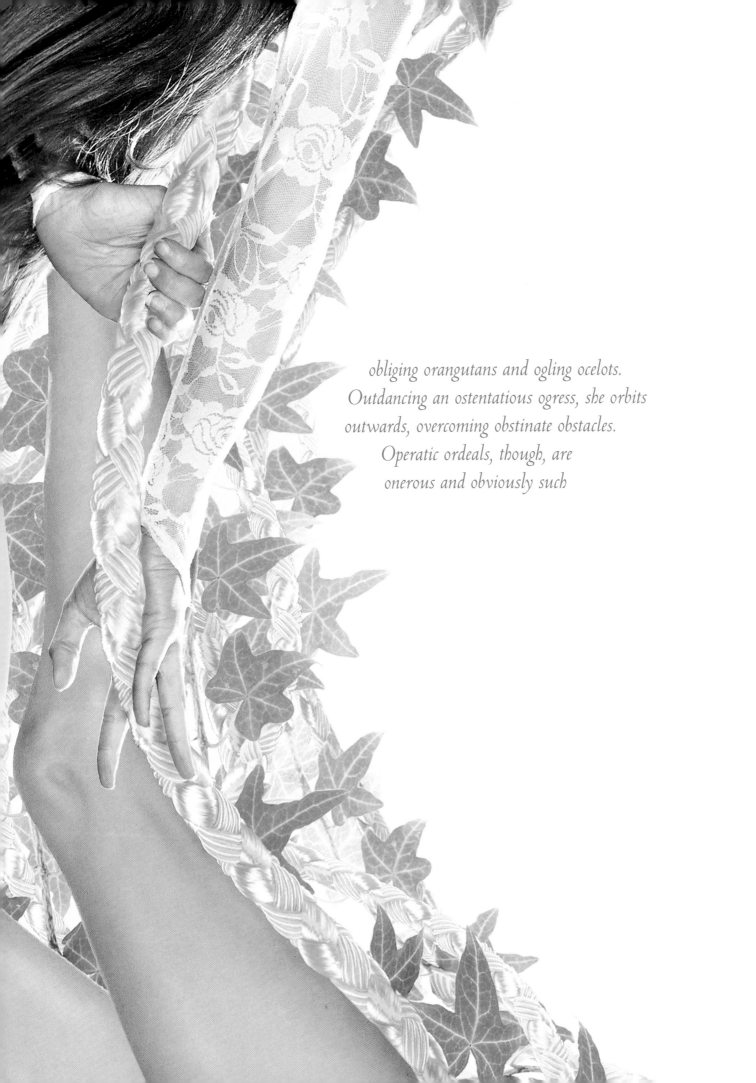

obliging orangutans and ogling ocelots.
Outdancing an ostentatious ogress, she orbits
outwards, overcoming obstinate obstacles.
Operatic ordeals, though, are
onerous and obviously such

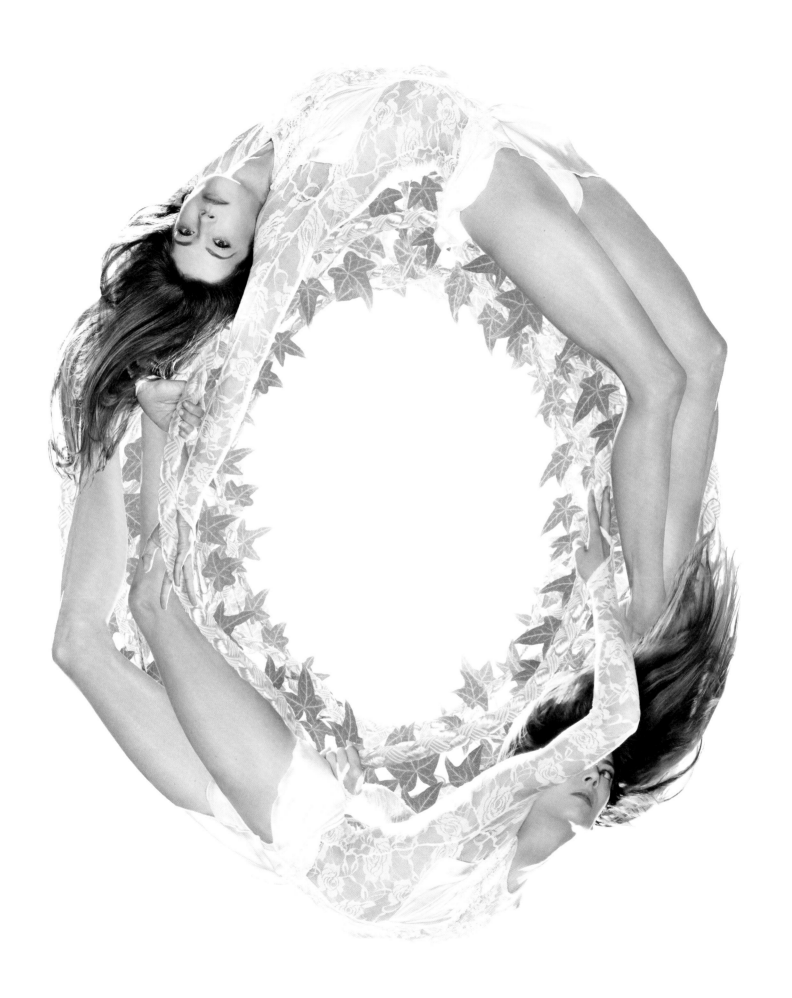

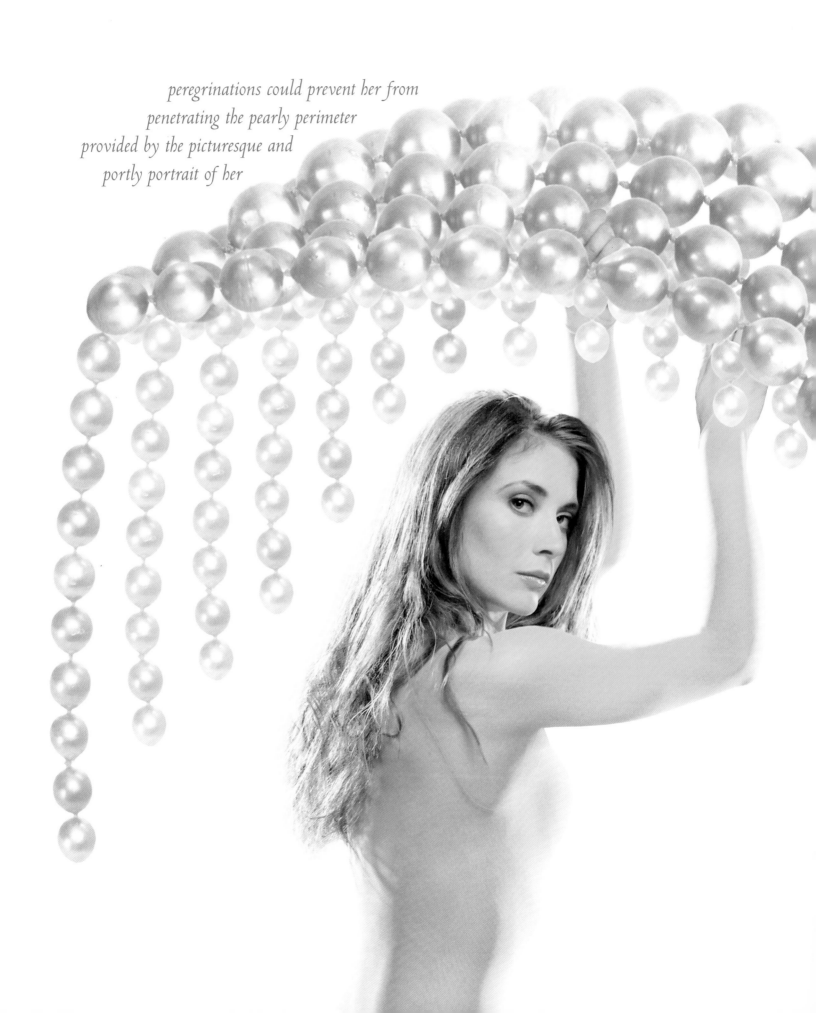

peregrinations could prevent her from
penetrating the pearly perimeter
provided by the picturesque and
portly portrait of her

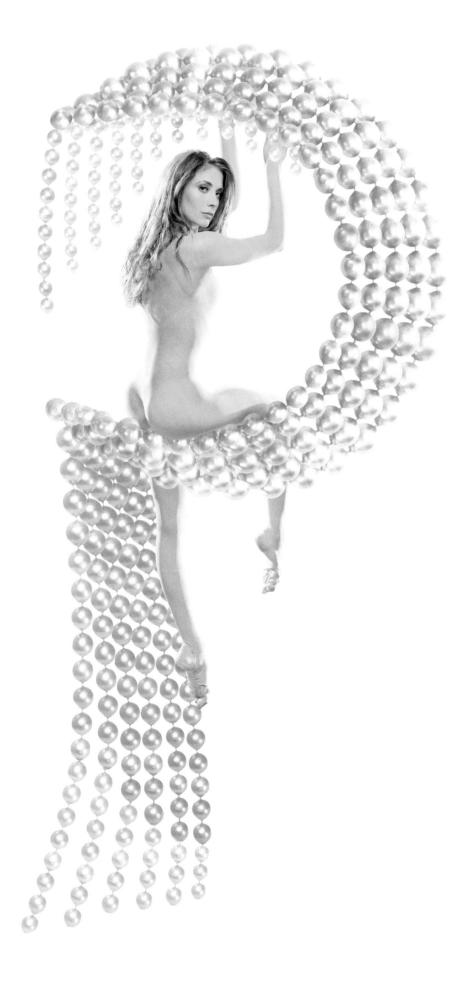

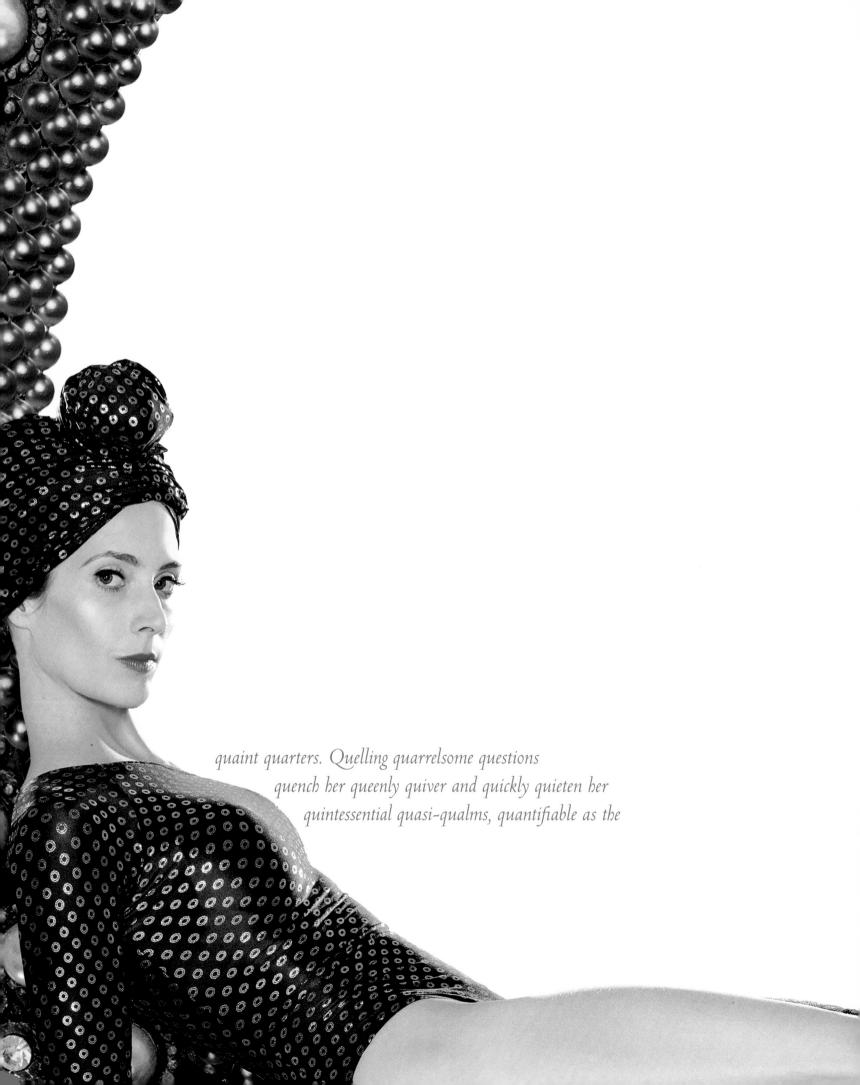

quaint quarters. Quelling quarrelsome questions
quench her queenly quiver and quickly quieten her
quintessential quasi-qualms, quantifiable as the

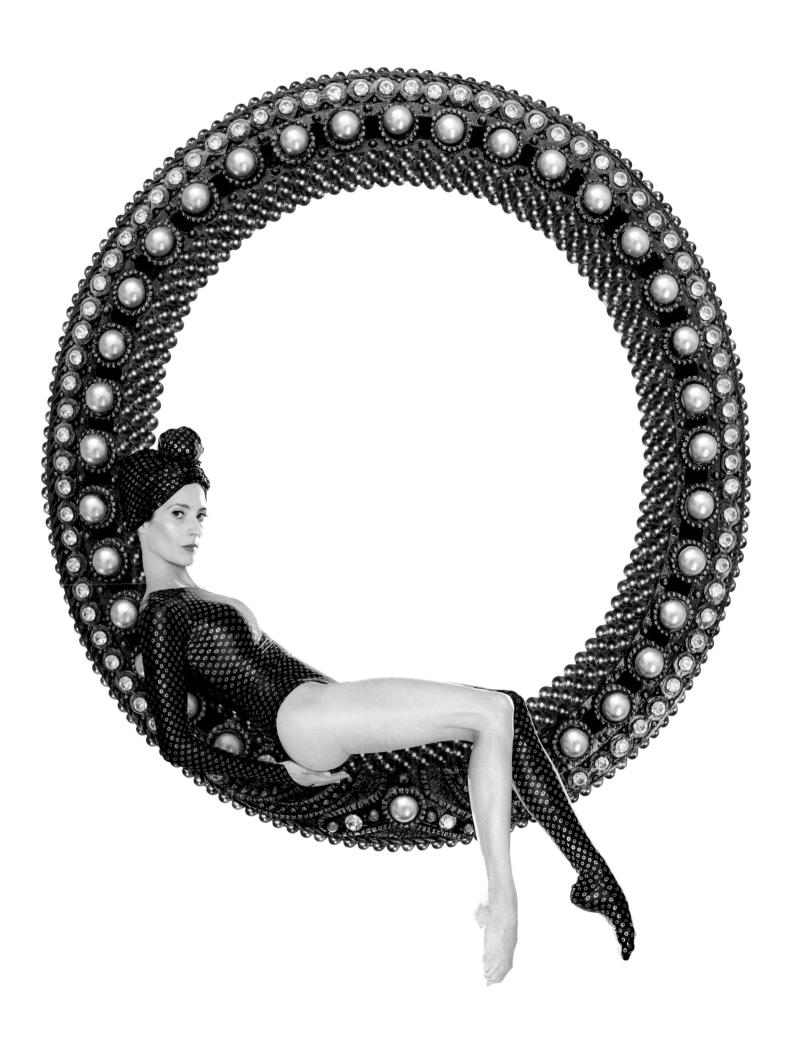

ramblings of a ravishing redhead. 'Really, it's time to reign in the verbal romp', she reflects, and ruefully reverts to more regular story-telling.

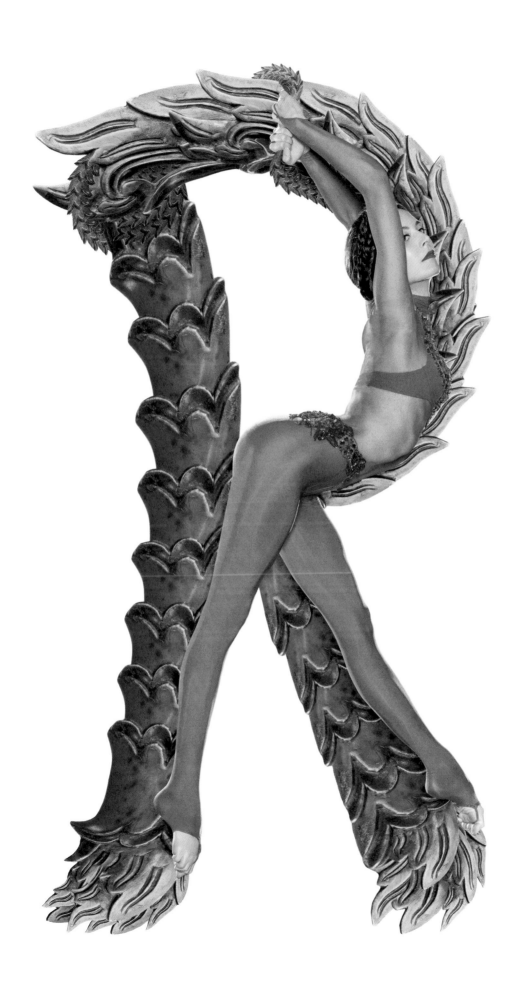

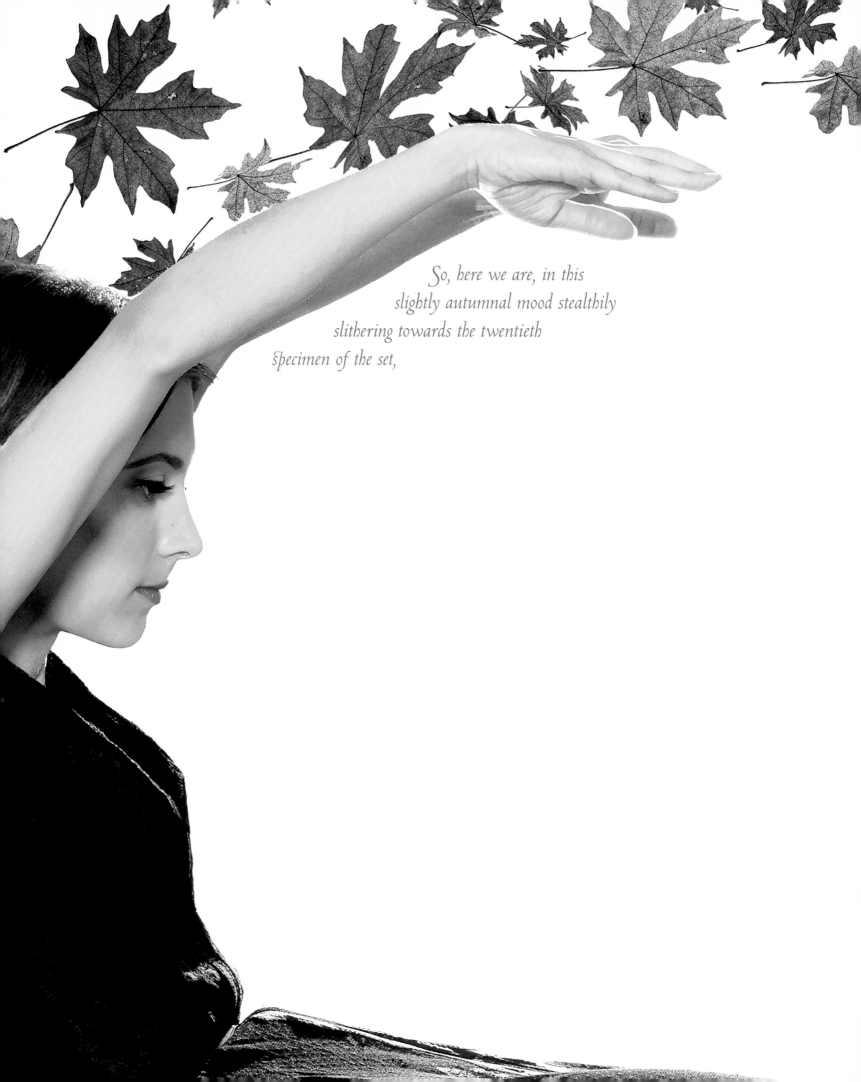

So, here we are, in this
slightly autumnal mood stealthily
slithering towards the twentieth
specimen of the set,

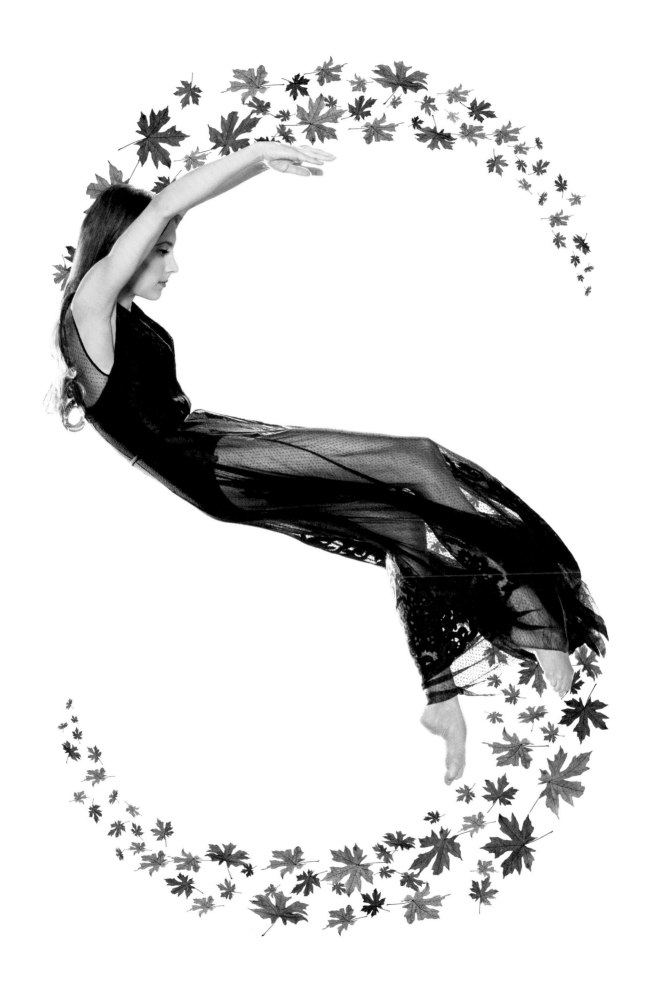

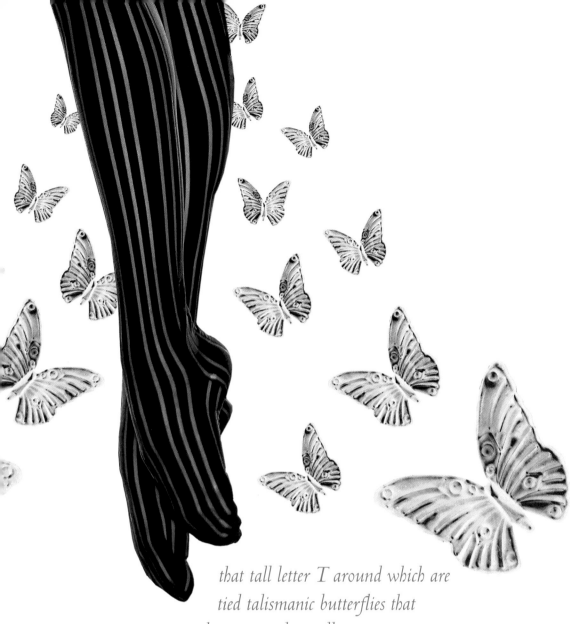

that tall letter *T* around which are
tied talismanic butterflies that
try to take our timid traveller to

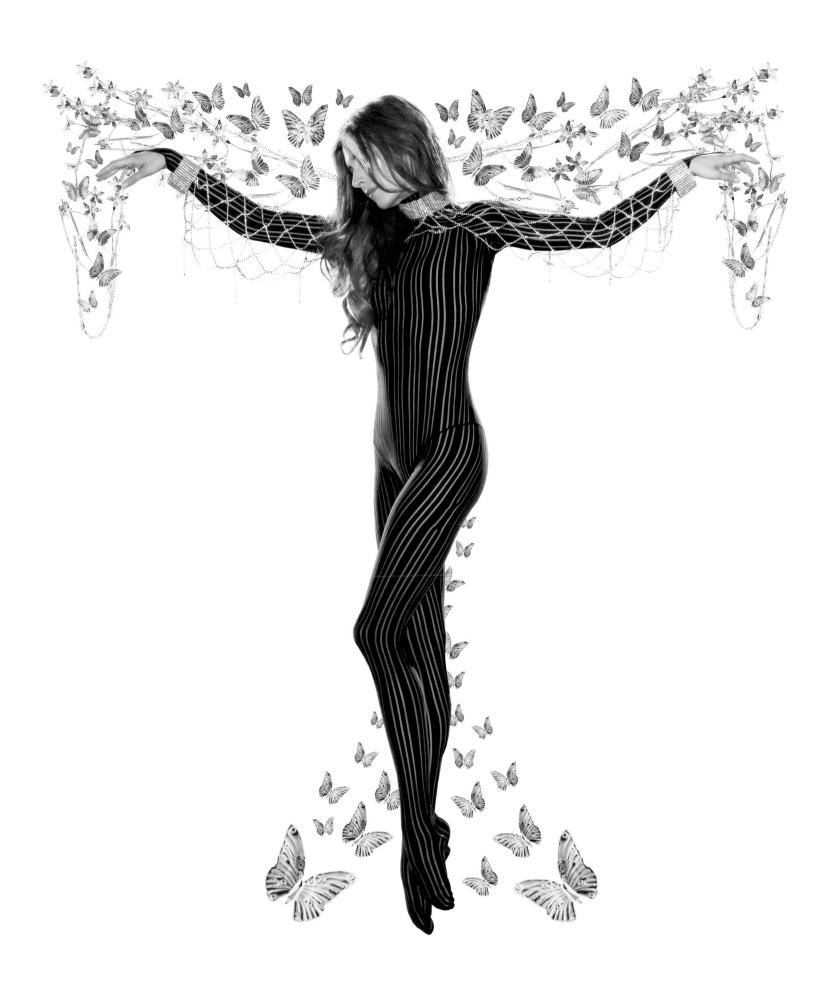

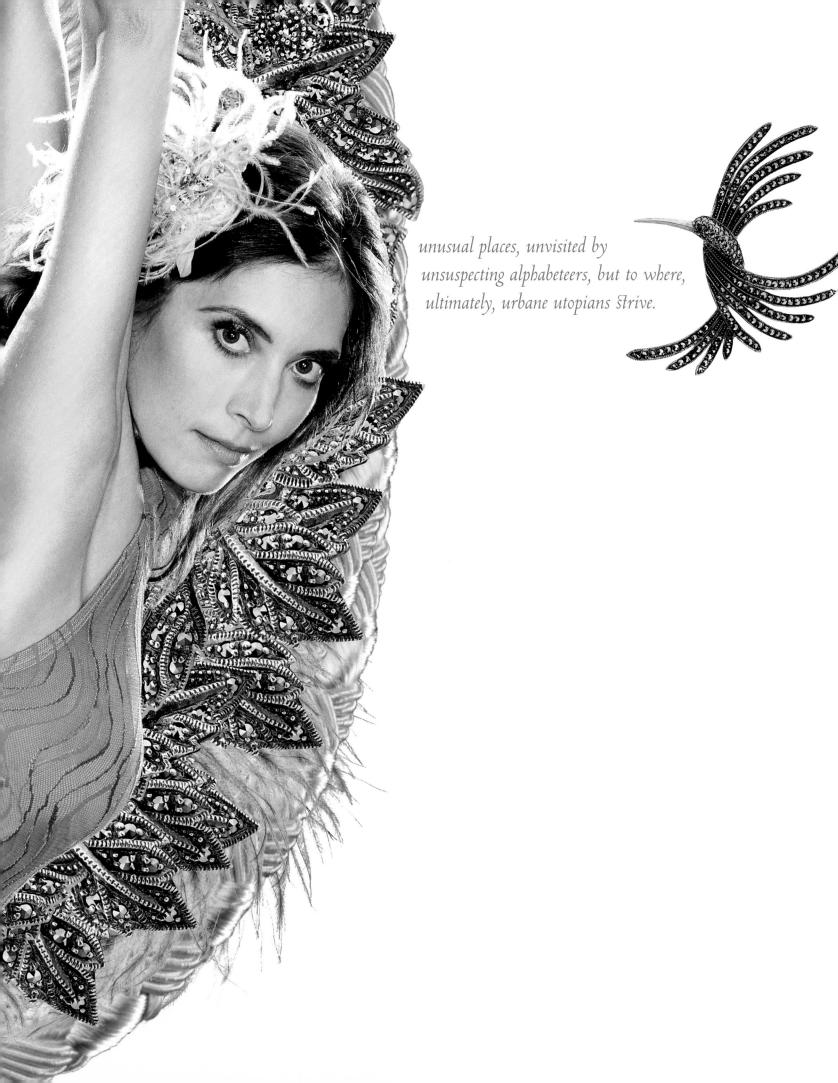

unusual places, unvisited by
unsuspecting alphabeteers, but to where,
ultimately, urbane utopians strive.

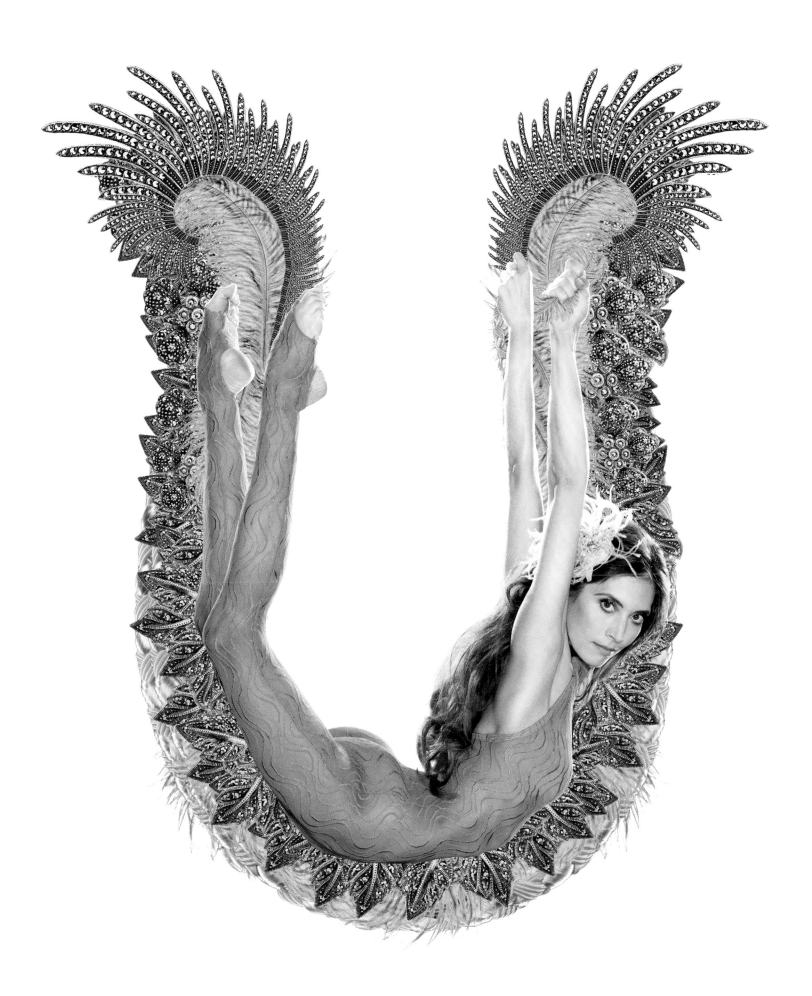

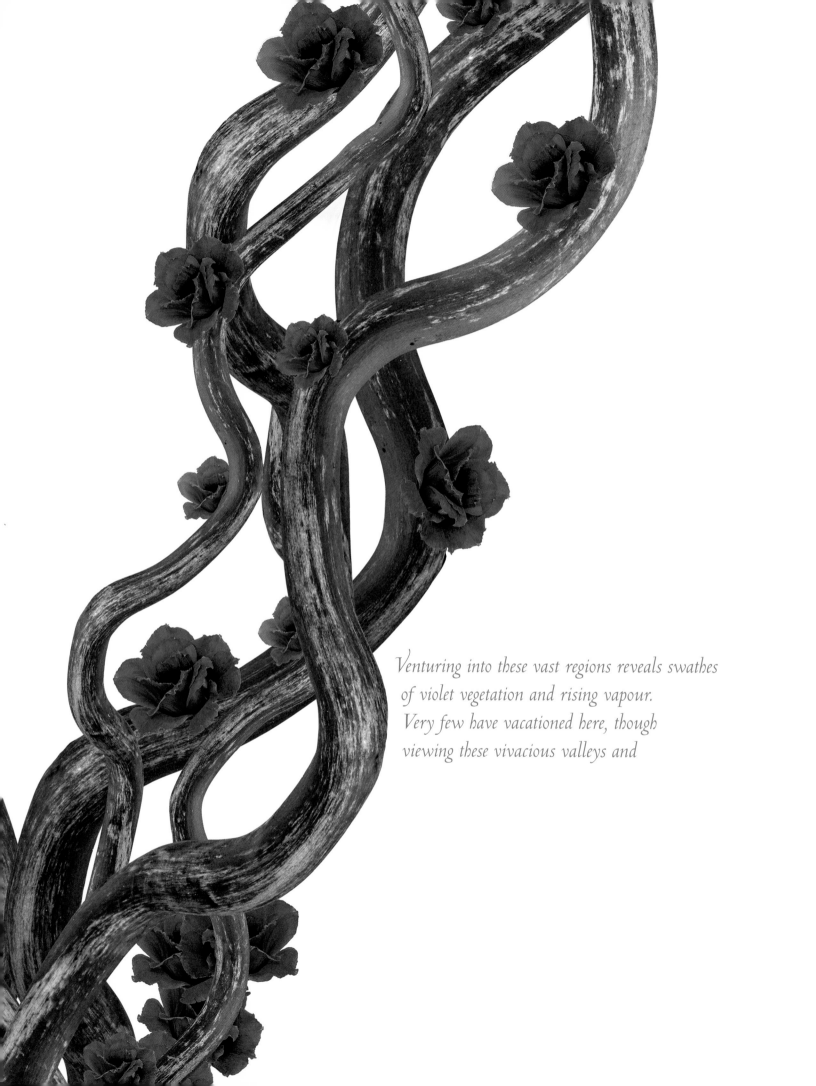

Venturing into these vast regions reveals swathes
of violet vegetation and rising vapour.
Very few have vacationed here, though
viewing these vivacious valleys and

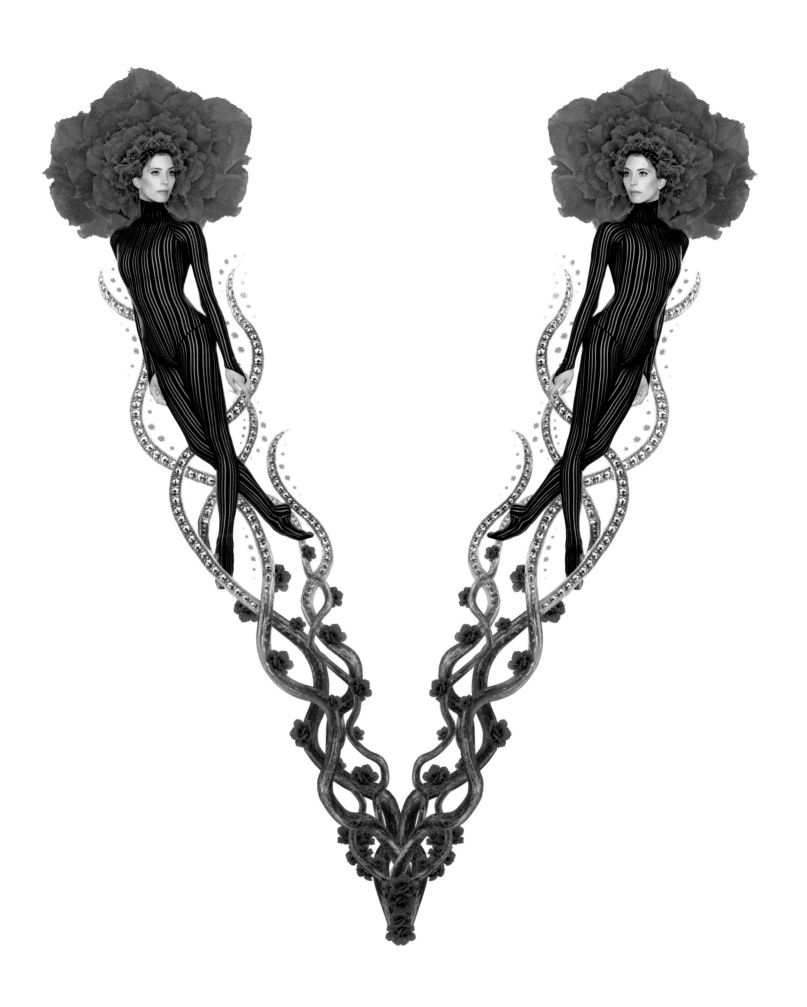

wondrous worlds where peacocks roam in the
wild without worry, one wonders why
we would not make our way there.

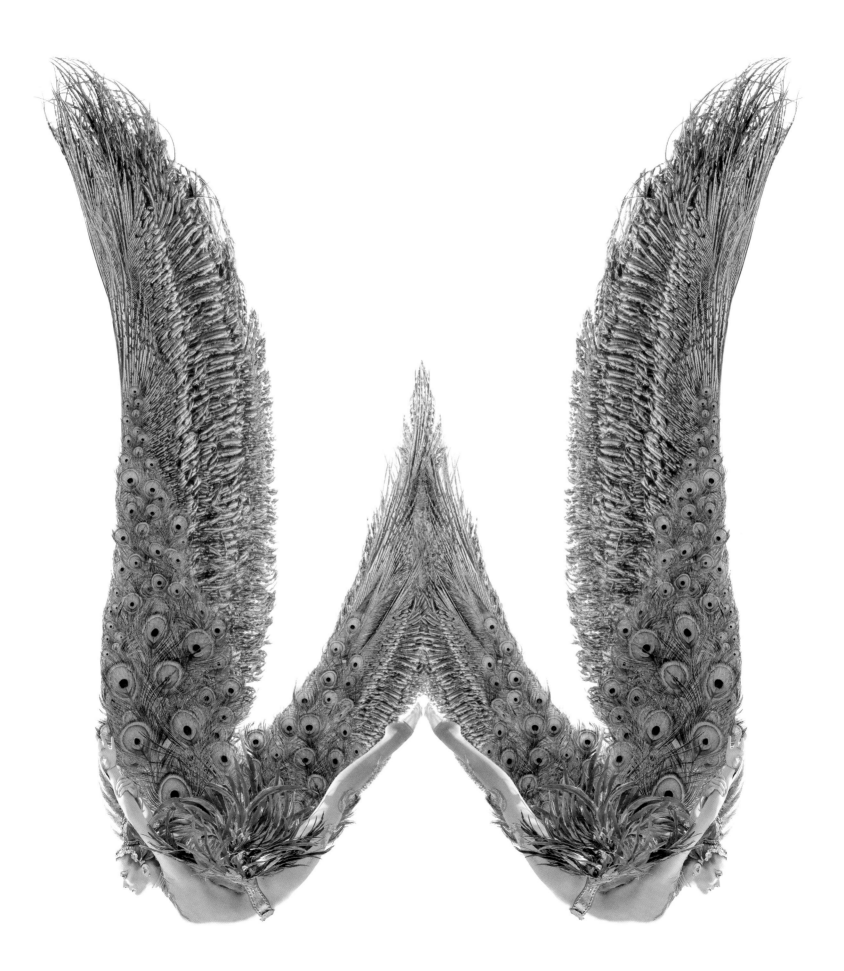

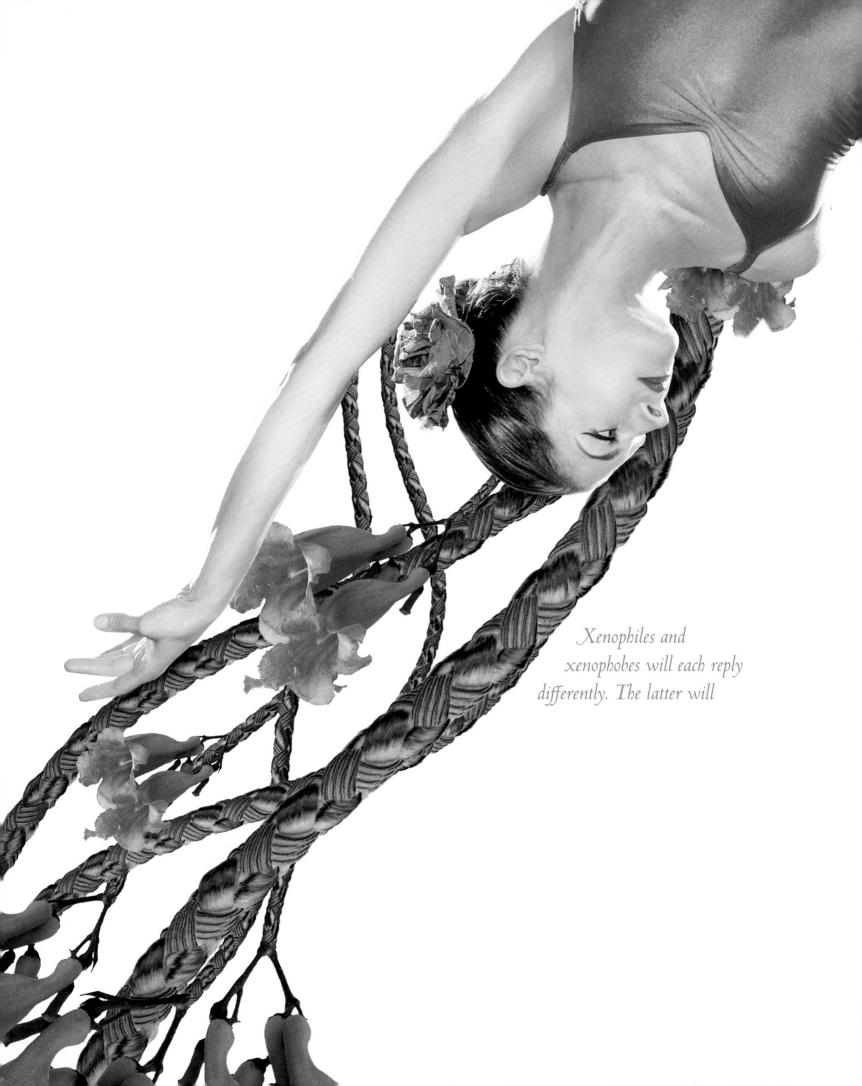

Xenophiles and
xenophobes will each reply
differently. The latter will

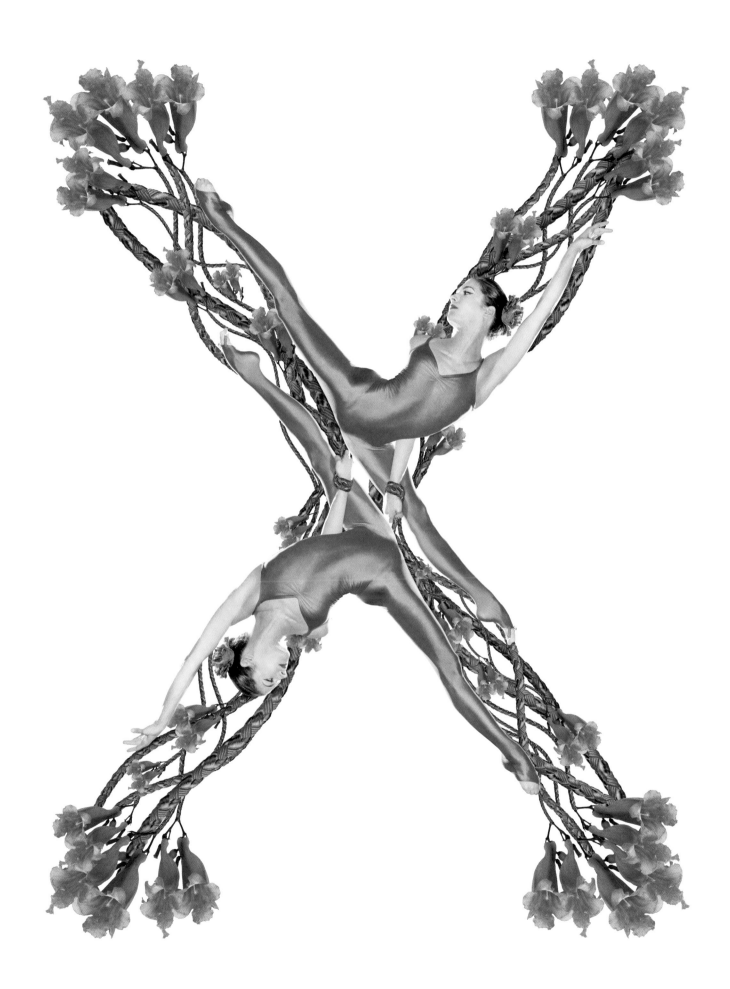

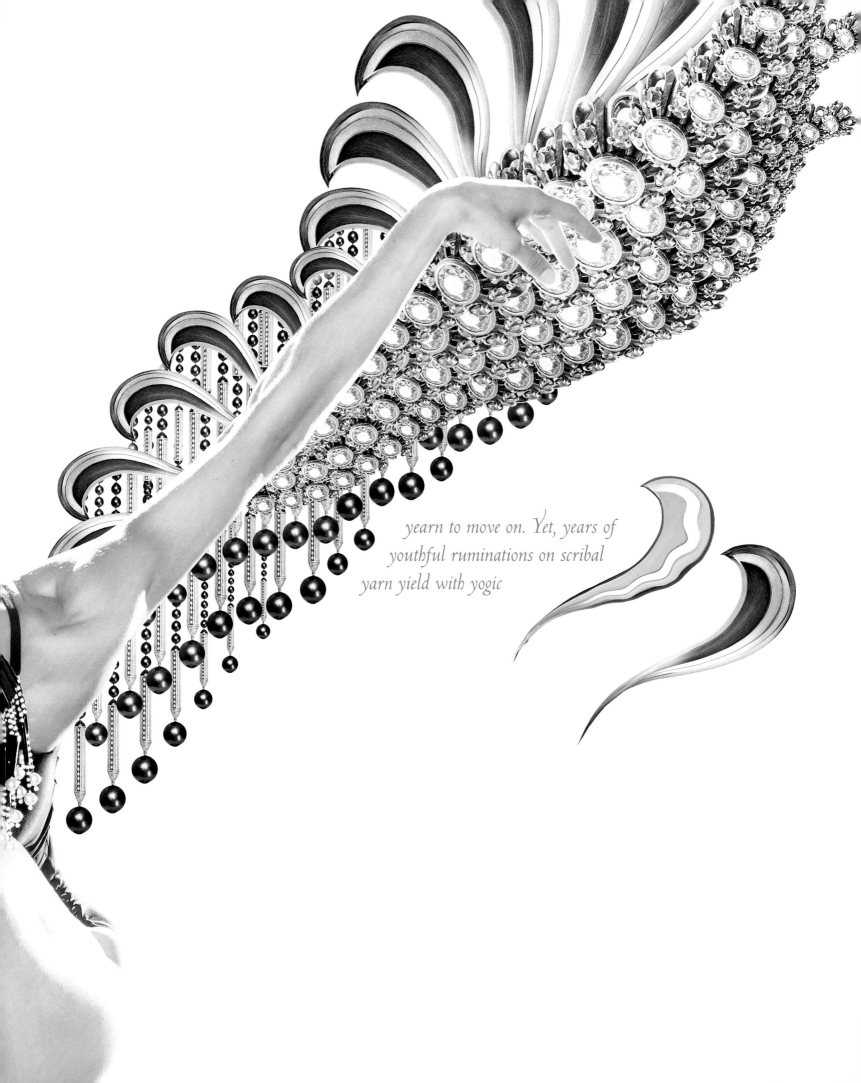

yearn to move on. Yet, years of
youthful ruminations on scribal
yarn yield with yogic

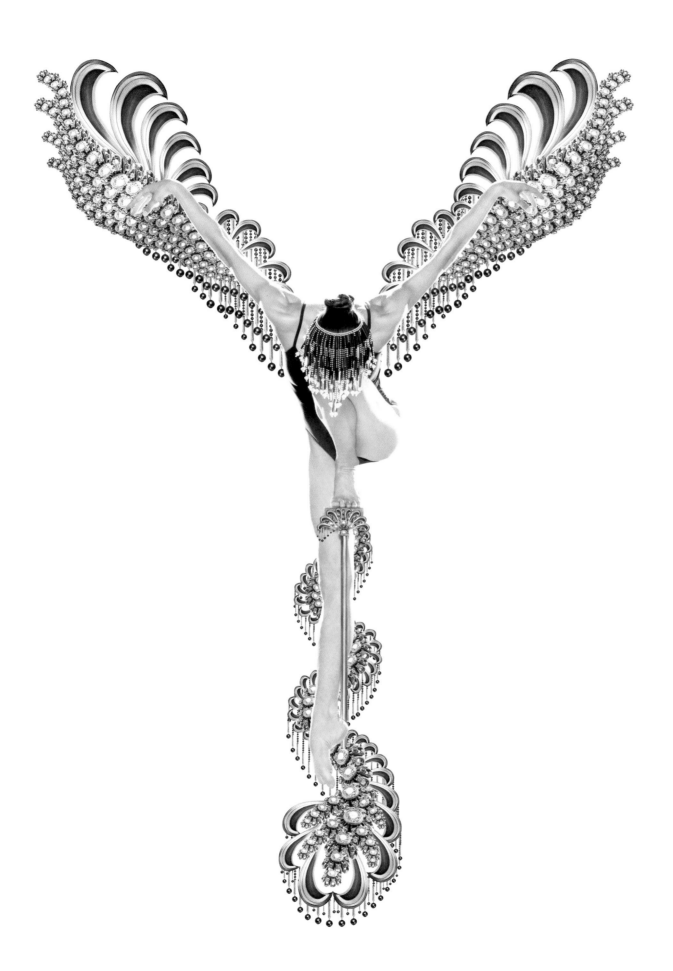

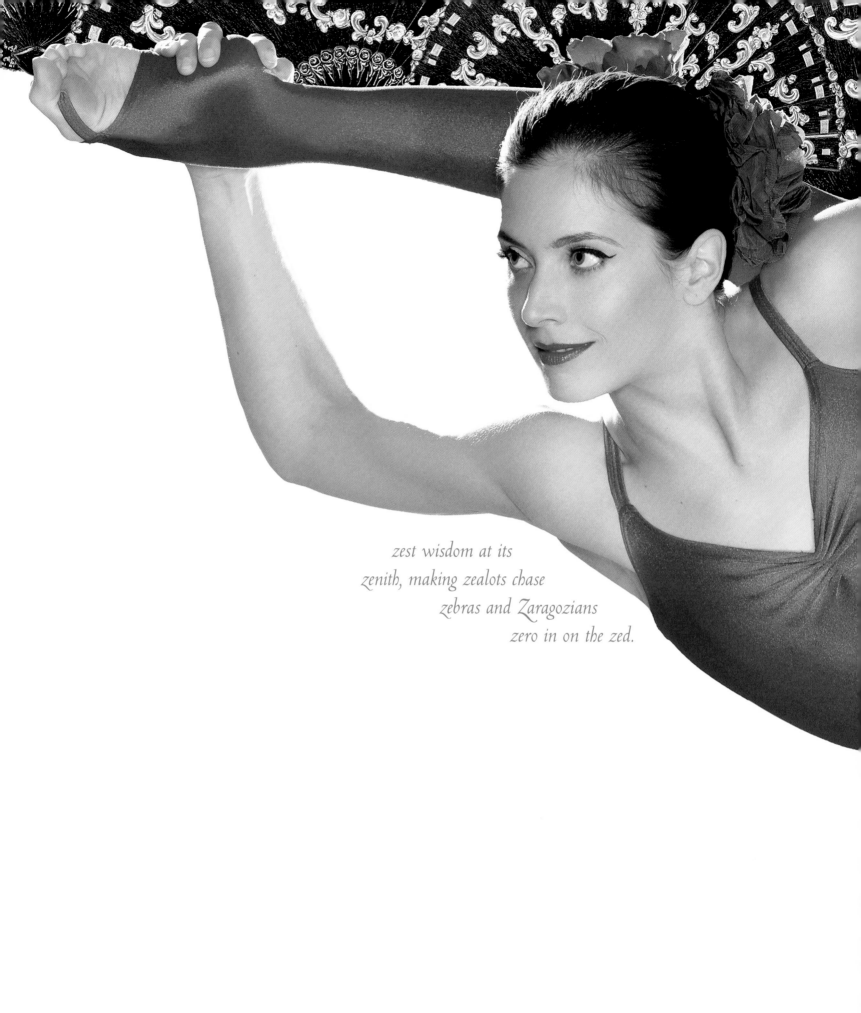

zest wisdom at its
zenith, making zealots chase
zebras and Zaragozians
zero in on the zed.

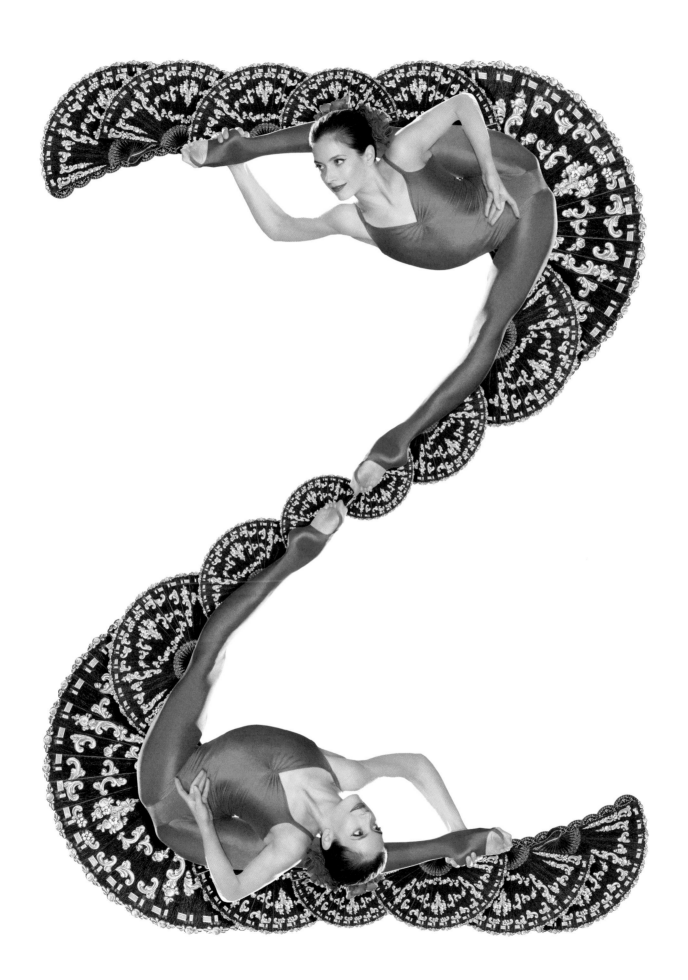

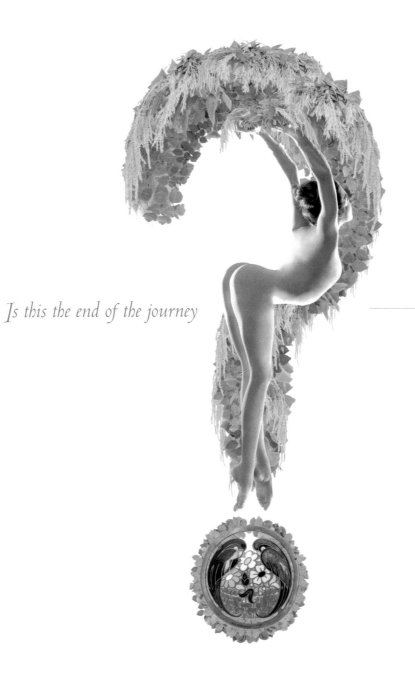

Is this the end of the journey

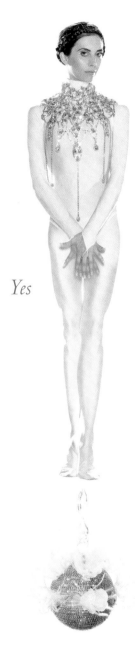

Yes

But wait, there is more to be said…

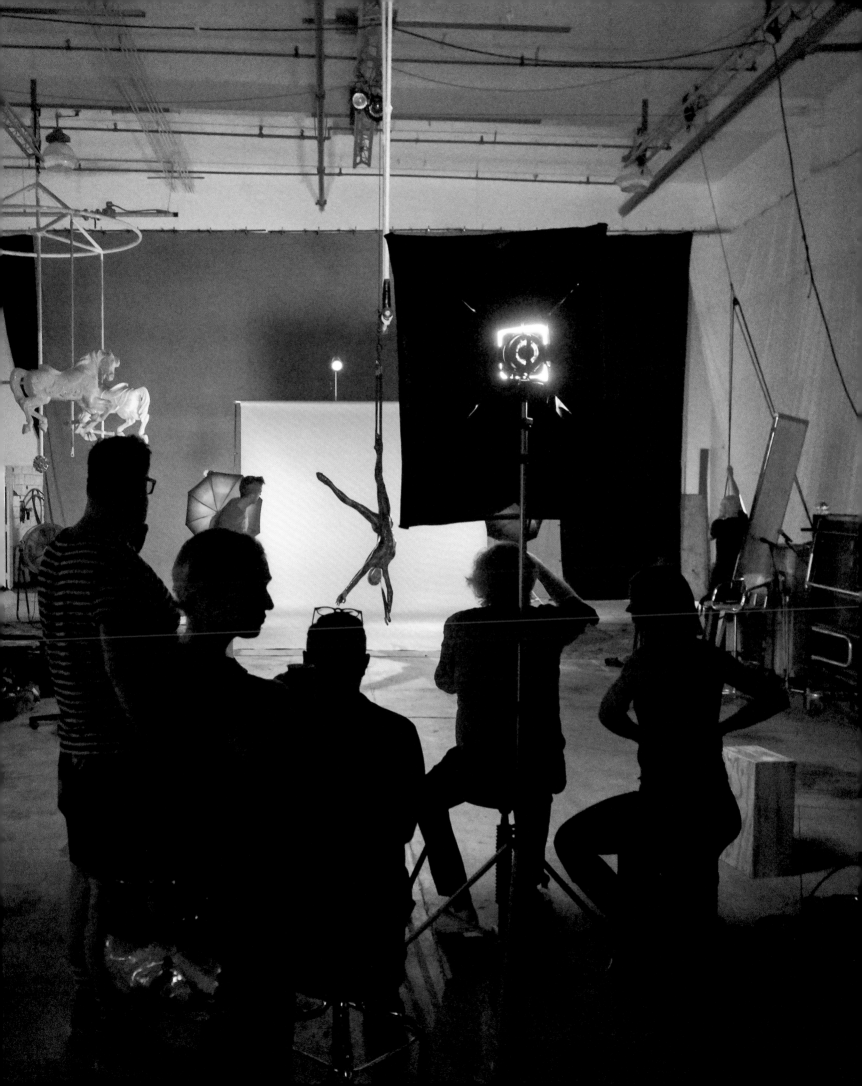

ERIKA LEMAY

Dancing in the sky

At the age of three, in early spring, my sister and
 I were sitting on our snow-dusted front porch.

Both of us were excited from the Easter festivities
 and the balloons we had been given.

Clutching them tightly, we were gazing into the
 whirling flurries of snow in the courtyard.

Drawn on our faces were the fearsome whiskers and
 stripes of a tiger, making us bolder than usual.

Excited, my sister turned towards me and whispered
 in my ear. 'Wouldn't you like to fly?'

'Fly? Yes,' I said. She stood up, spread her arms, held
 tight to her balloons, and jumped off the porch steps.

Gracefully brushing off the snow after her short
 flight, she looked suggestively at me.

'Higher', I called. 'I want to fly higher!'
 She had given me an idea.

I was smaller than she was, so maybe the balloons
 could carry me farther, propel me high into the sky.

Jumping up, I danced to the edge of the porch and
 pushed off with all the strength I could muster.

Knowing that I would fly, I was surprised
 to find myself on the ground so soon.

Lo and behold, I had let go of my balloons,
 which were drifting forlornly up and away.

My heart broke. They had escaped without me,
 and I cried my tiger make-up away.

Nevertheless, a part of my being had been
 awoken. I had found a reason to be.

One day I would fly. I would reach higher
 than any balloon escaping me.

Physical Poetry was still far in the future,
 but I embarked on a journey of discovery.

Questions arose, failures multiplied, hours
 of practice sometimes amounted to nothing.

Regardless, through all the hardships and
 disappointments I always remembered my dream:

Someday I would fly. Someday
 I would dance in the sky.

The journey, with all its ups and downs,
 was finally taking off. I found myself

Up, up in the sky with my balloons, performing all
 around the world. I had become a flying princess,

Venturing ever higher, on ever bigger stages, leaping,
 swinging, bouncing, bending, balancing and rolling.

With the power of my passion I am flying,
 but where will I land;

Xi'an in China? London, Rome, New York, Montreal –
 or maybe Los Angeles in the Kirkland Studio?

Yet, up in the air, too far above to communicate
 with anyone, I never feel alone.

Zero gravity is my closest friend,
 the mender of my broken heart.

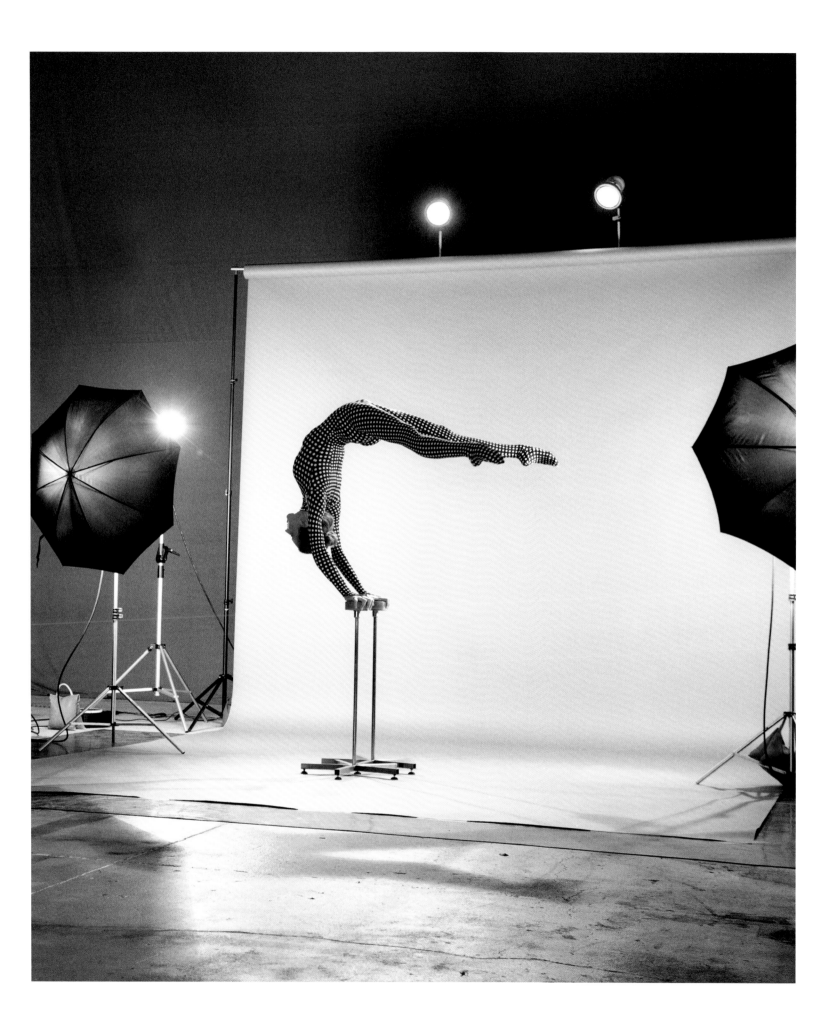

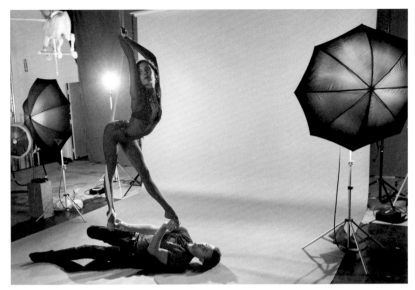

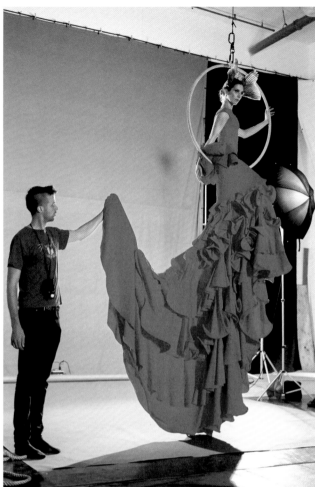

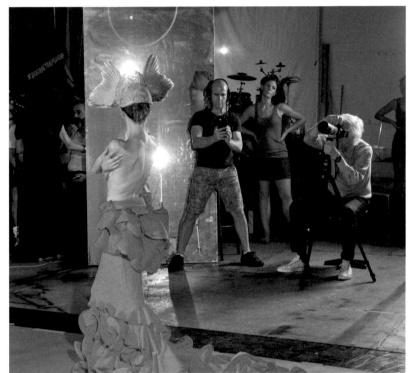

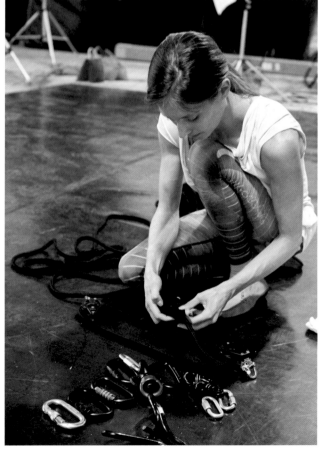

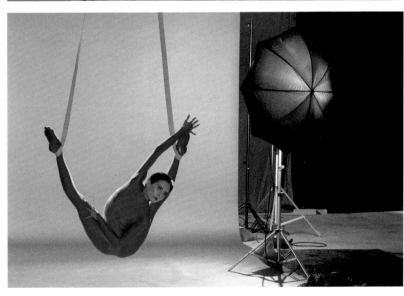

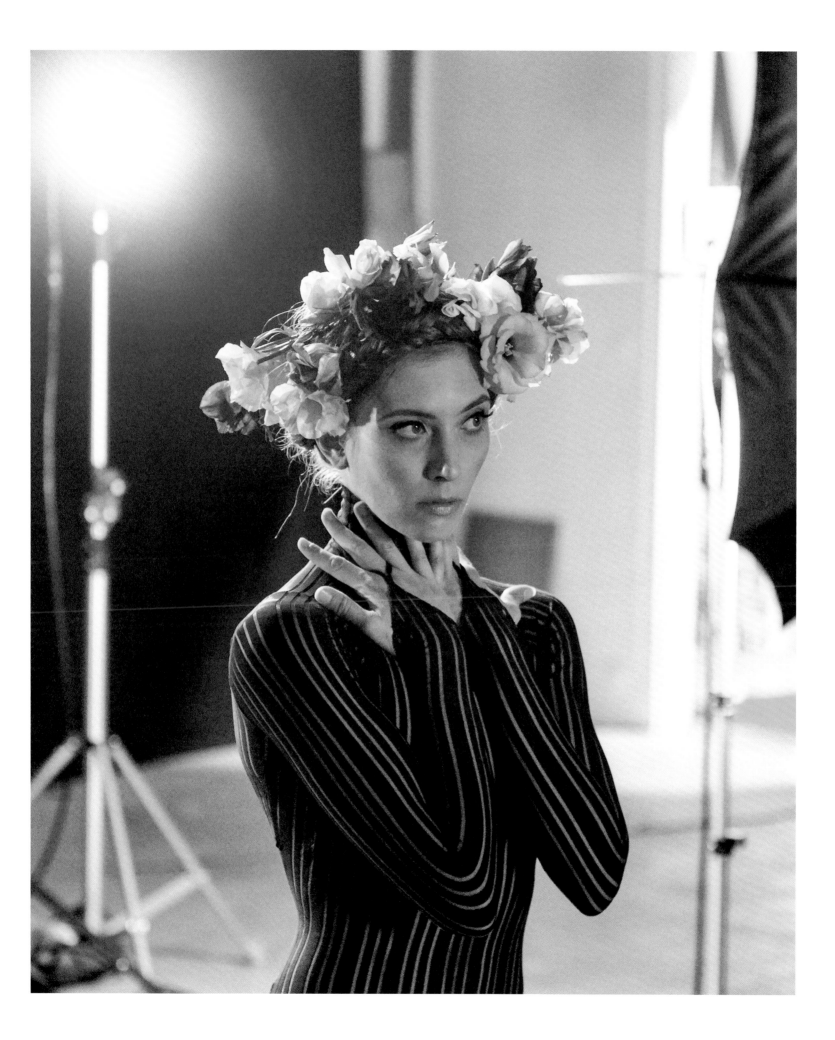

WILLIAM THOREN

Element design

I FIRST MET DOUGLAS AND FRANÇOISE when my high school photography teacher recommended I reach out to them for an internship. I showed up at their house with long shaggy hair, dirty hiking clothes, my portfolio of landscape photography and a few portraits of…animals. Douglas didn't know what to do with me. He flipped through the pages of my portfolio and seemed genuinely impressed with my landscape images and then called for Françoise to come take a look. 'Maybe you can give me an assignment to shoot, which I can bring back later for a critique?' I asked, looking around the walls at all those iconic portraits. 'I don't really know portraiture but I would like to learn.' Douglas seemed a little puzzled. He and Françoise looked at one another. Françoise turned back to me and said, 'I think that's a wonderful idea!' Before I left, each of them gave me an assignment. Françoise asked me to shoot my interpretation of the words Earth, Wind and Fire. Douglas asked me to photograph my parents as I would want to remember them when they are no longer here. He said many photographers overlook photographing those closest to them and later regret it. He showed me pictures he had taken of his parents and told me how much those images meant to him. This was the beginning of my mentorship.

Working for the Kirklands is a family affair. They treat their assistants like their children, and they treat everyone around them like family. Douglas is just so genuinely interested in people that he forms close relationships with anybody he regularly interacts with. In my mind, that is what makes him a great photographer. He can get a wide range of people he has never met before to open up and feel comfortable with ease.

To me, Françoise is an artist who uses life itself as her medium. This talent is evident in everything from the beauty of her physical environment to the melting pot of interesting personalities she keeps flowing through their home in an endless stream of small parties and intimate gatherings. The way Douglas and I passionately assess the last shoot, or the quality of light, she assesses the last gathering of friends, and the quality of the conversations. Their house feels like a living gallery, with objects from many worldly travels, iconic and obscure artworks, and beautiful gardens. The environment is so stimulating that it makes it very hard to leave as an assistant. I worked for them for two years and eventually went off to pursue free-lance work and a musical career playing the didgeridoo. But I somehow never really left, as they would still call me back a few times a year to help with bigger shoots. One of these bigger shoots turned out to be this alphabet project.

Part of the magic of the whole experience was the spirit of spontaneity running through the project, starting with Françoise's vision and ignited by the contributions of the lively mixture of collaborators. Françoise had been wanting to do this for years and finally decided to just go for it. It was kind of like solving her giant complex puzzle with a group. The vision in some ways was very clear to everyone, yet no one knew how it would specifically turn out. Erika, Simone, Douglas and Françoise were figuring out many of the concepts during the actual shoot. Françoise and Erika had brought a few ideas for how the body could form certain letters. We were uploading the shots for Douglas and Françoise to assess as we went along. While they were assessing, we were using the green screen

and Simone's wardrobe for majestic images of ridiculous grandeur – a process Simone has down to an art. Most of the cast and crew were staying at 'château Kirkland' for the whole week of the shoot. Each day we ate every meal together, worked all day together and finished each night with a glass of wine and laughter in the jacuzzi.

I got very excited when I saw that they were planning on photographing elements separately to composite each letter. I had been doing a lot of intricate Photoshop composites and was very passionate about that kind of work. I knew it would be a huge task to build these elements around Erika and I offered to take on that digital mission. I didn't realize that it would turn into a year-long project that would have me literally living in their house half of the time.

After the epic production that was the initial shoot, the following months consisted of an intimate creative process between Douglas, Françoise and myself. Françoise has been a major part of who the world considers Douglas Kirkland to be. She is a powerhouse of work, vision and integrity when it comes to preserving, inspiring and maintaining Douglas's legacy. They work together as one person in many ways. What excites me the most about the final result of this project is that it truly represents a visual marrying of their two personalities. Each letter carries the

same sort of eclectic and refined flavour that is Françoise, with the visual mastery of Douglas Kirkland. Throughout the entire process, they each had very different feedback for how to move the design process forward. Douglas was more concerned about how the elements showcased, and made his images of Erika sing. Françoise was more focused on the overall big picture and theme of the entire project.

My job was to take the chosen elements and mock them up around each image of Erika, and then get further direction or approval for each concept. Françoise drew rough sketches around the existing images of Erika, sometimes collaging images from magazines and sometimes leaving more room for interpretation on my end. Certain elements were planned for before shooting Erika, such as the roses for the A and the birdcage for the J. Most of the others were invented after the initial shoot was finished, and often inspired by Simone's wonderful outfits.

We photographed hundreds of elements, including flowers, leaves, vines, jewellery, antique ornaments, lace, feathers, silverware, serving trays, silk ropes, moss, a giant antique birdcage and a Flamenco fan that we spent an evening searching for in the streets of Madrid. Everything in these images was some object we found. I was prowling the neighbourhood and streets of west Hollywood for plants that might enhance certain letters. As the intricacy of one letter increased, so did the rest of the letters to uphold a theme. For every letter, there were at least three complete alternate versions using different elements.

When all of the final elements were chosen and all of the designs were approved, the printing process began. It took us months just to clean up the edges of all the elements and make them blend together in each letter. I brought in Samuel Herndon to help me with the final details after months of missing deadlines. Even then, it took another several weeks to make corrections under the guidance of Douglas's master eye before we finally stepped back and simply let the images enchant us, as I hope they enchant the readers of this book.

ABOVE: *Simone Guidarelli and William Thoren on the shoot of* Physical Poetry Alphabet; RIGHT: *Françoise's sketches*

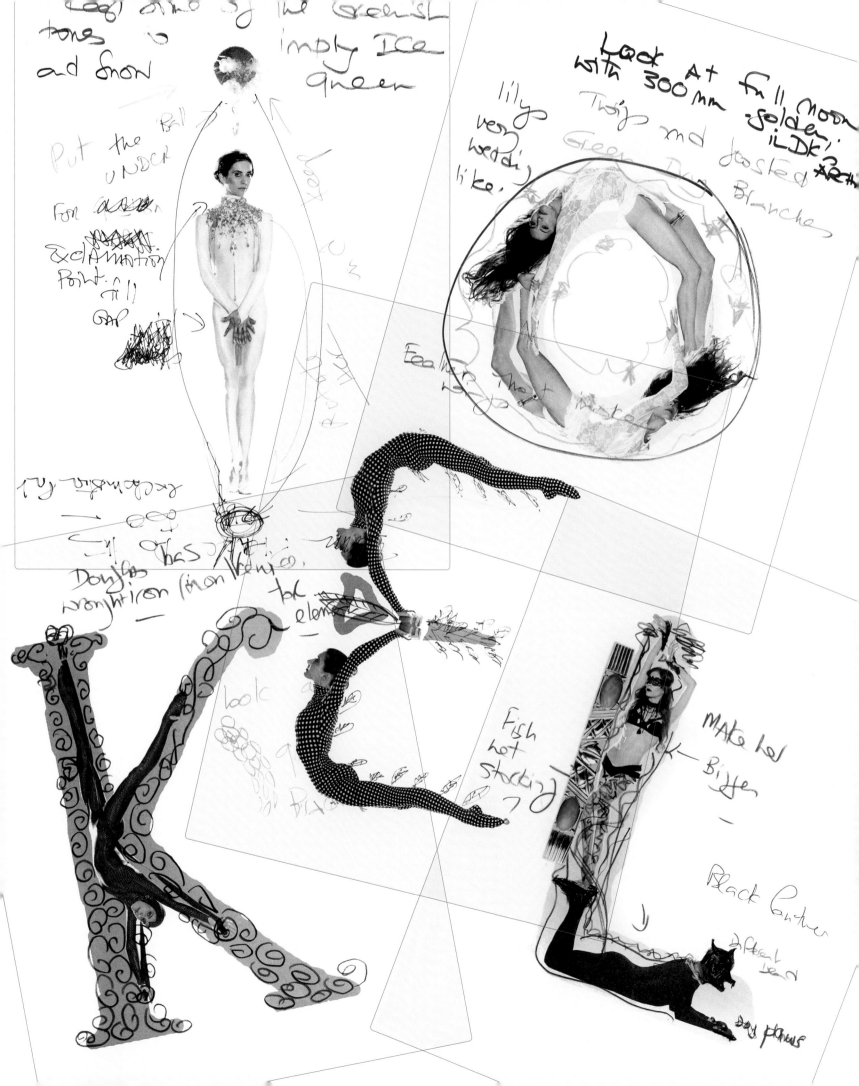

L'inspecteur des travaux finis

I GREW UP ON THE LEFT BANK in Paris. In our household we were always passionate about art and design, and no less thrilled by the people who make it.

My stepfather Steve was the Paris bureau chief of the London *Sunday Times*, a well-known political journalist who wrote novels by night. My mother, Simone, spoke three or four languages and had a college education – an unusual feat for a woman of her generation. My father worked for Publicis, a public relations firm; he loved American cars and spent his spare time combing the *brocantes*, or flea markets, for antiques, rare books and all sorts of other eclectic objects. My stepmother was a fashion illustrator. My maternal grandmother, still a great beauty in her 70s, was the most eccentric of them all. She had opted for independence rather than a boring marriage. She was a painter who made a living by hand-tinting photographs for the famous Studio Harcourt. It was not unusual for me to bump into her at Les Deux Magots, where she would hold court alongside Salvador Dalí and Gala and, of course, their pet ocelot Babou. She had perfect posture and wore a beige beret pinned to her hair. For no apparent reason, but with blue eyes twinkling (I inherited those blue eyes), she would enumerate the many men she had had in her life: Aristotle, Plato, Socrates…Not your typical French bourgeois household!

In the Quartier Latin and around Saint-Germain you would run into all sorts of types: one day it would be Raymond Duncan, Isadora's brother, who walked around in his robes and sandals in any season; another day, the French sculptor César in his Mini Moke. At home, a typical dinner party would include Constantin Nepo, a most handsome Russian portrait painter and actor; his wife, the ballerina Yvette Chauviré; abstract painter Bona de Mandiargues and her lover, Mexican poet Octavio Paz; surrealist painter Leonor Fini and her two lovers Stanislao Lèpri and Konstanty Jeleński (both of whom, by the way, shared her atelier along with more than a dozen cats). Everyone got along very well and conversations were always lively, though I remember, much to my dismay, hearing the grown-ups shouting at each other. But for my parents that was the gauge for a great evening! My stepfather would comment cheerfully the next morning on what a delightful gathering it had been.

My parents did not have a lot of money, but they had impeccable taste. Sunday mornings we would either go to the Marché aux Puces to hunt for treasures or to the Louvre to look at treasures. Our walls were covered in art, be it paintings by Piet, the graphic art of Aubrey Beardsley or the sinuous Art Nouveau designs of legendary poster artists Alphonse Mucha and Paul Berthon. I was especially drawn to the works of the Russian-born designer Romain de Tirtoff, better known as Erté (the pronunciation of his initials, R T, in French). Most memorable was his breathtaking *Alphabet Suite*, a whole alphabet made of sprightly nymphs and fantastical beings formed into the shape of letters.

I am always surrounded by reminders of this stimulating and fascinating childhood. One of my fondest memories is of my stepfather waking us all up in the middle of the night to admire an autumn leaf he had pinned in an empty gold frame on the wall. That very same gold frame now hangs on the wall of our house in

the Hollywood Hills, waiting for the occasional leaf or found object to fill it for a while.

All these wonderful memories have been a constant source of inspiration throughout my life. But when Erika Lemay came into our lives in 2008, the final piece of the jigsaw that was to become *Physical Poetry Alphabet* fell into place. Erika was a wonderful subject and Douglas adored photographing her: she was full of youth, fragile yet exuding power. She modelled fashion for *Vanity Fair* Italy while suspended from blue silks, hung upside-down wearing a parka for Woolrich and inspired a short conceptual film that Douglas directed and aptly named *Objet de Désir*. It was during this shoot, watching her perform, that I was struck by a pose which reminded me of a perfect letter T. Erté's delicious *Alphabet Suite* rushed back into my mind and gave rise to the idea of creating a whole human alphabet starring Erika. Douglas was sceptical. I persisted.

It finally all came together the summer of 2015. The stars all seemed aligned and a dream crew arrived from all four corners, from Los Angeles, Milan and Quebec, though we really had no idea what we were getting into. It was supposed to be my 81st-birthday present to Douglas, but, who knows, perhaps it would become a poison cake.

The shooting took place in a huge cavernous warehouse with very high ceilings downtown, tellingly called 'Way 2 Much Entertainment'. The beginning of any project involves a lot of planning. Douglas's philosophy is that all the equipment and lighting should be in place and function seamlessly to avoid distracting from the one and only star on his set, *his subject* – in this case Erika. While shooting no one is allowed to talk, at the risk of being reprimanded by the Maestro. To everyone who knows him, Douglas is a very mild-mannered man, but on set, when he is shooting, he turns into this intense creature with very little patience for mistakes. A long time ago, I used to wonder if he was in a bad mood, and when I asked him about it, his answer was a curt: 'I am concentrating!'

The first time he photographed me, over 50 years ago, I thought he was mad, but I came to realize that is what makes him an exceptional photographer and creates the unusual connection with his subjects. Just so here: Douglas and Erika would huddle together looking at the back of the camera, endlessly discussing how to improve every pose. In the meantime, our assistants would download the files and we would look through them trying to imagine what the finished letter would end up looking like. I remember the whole experience as a dream, our house brimming with excitement and me playing ringmaster to our little circus.

Then came the endless, nearly two-year-long task of finishing each letter. Many sentimental objects found their way into these final letters: my mother's diamond cocktail ring; my grandmother's brooch. A silver hand-mirror frame with its mirror missing. We got up at dawn and bought enough flowers and plants at the downtown flower market to turn the house into a greenhouse. Will and my nephew Lucas went on a feather hunt – we could have filled a dozen pillows with their loot. Being a night owl, Will worked all night and emerged bleary-eyed around midday to fry himself his famous 'eggs in the hole'. The flashing of strobes in our studio illuminated our bedroom at three in the morning as he photographed elements for the design, lost in the music blaring in his headphones. I threatened and cajoled, seeing no end in sight. But he carried on, meticulously refining each letter, and when I saw the finished product I had to admit: the results were thrilling. Then Douglas would come along and ask for yet more changes. I would rage and call him *l'inspecteur des travaux finis*. He was invariably right. Finally, when all was done, we were almost sad to let it go.

But wait – it was not over, then came along the magicians: Ornan, Num and Mona at Sylph Editions. They created the book we had envisioned and hoped for, but far better and beyond our greatest expectations. For that we are forever grateful.

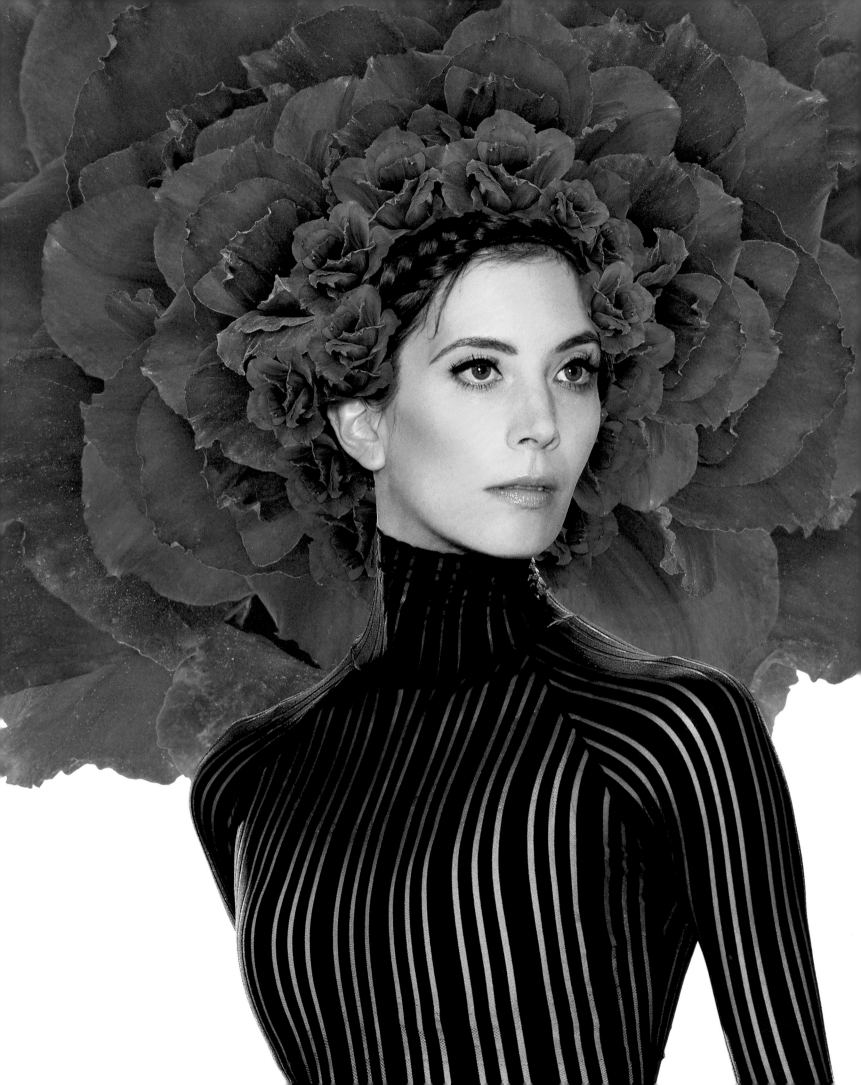

COLOPHON

Physical Poetry Alphabet

© Douglas and Françoise Kirkland, 2018

Introduction and literary nonsense verses: © Ornan Rotem, 2018
Individual articles: © the authors, 2018

CAST AND CREW

Fearless Leader
Douglas Kirkland

Gypsy Queen
Françoise Kirkland

Enchantress
Erika Lemay

Wizard
William Thoren

Fashion Alchemist
Simone Guidarelli and his apprentice Massimiliano Galli

Illusionist (Hair and make-up for Cloutier Remix)
Jenna Garagiola

Genies
Marco Acerbi, Miranda Boller, David Coffey, Samuel Herndon, Mark Kirkland, Zander Roberts, Cassandra Summer and PhotoOp: Livia Corbo, Marta Cannoni and Angelica Allende

Magic Cauldron Elixirs
Michael Burke & Angie Ann – Eat.Drink.Americano.

Sirens and Charmers
Keiko Noah and her tribe – Mouche Gallery Beverly Hills

Enchanters
Porselli Milan, Sharra Pagano, Chiara Boni La Petite Robe, Fiori Couture

Magic Dungeon
Way 2 Much Entertainment

Magic Wands and Technical Support
Canon USA and the Explorers of Light program, Rob Altman, Jesica Bruzzi, Tony Kano, Amy Kawadler, Len Musmeci, Dan Neri, Eliott Peck, Elizabeth Pratt, Rich Reamer, Doris Tsai, Peter Tvarkunas and Arthur Van Dover, and Moab by Legion Paper

PICTURE CREDITS: p. 8 left: *Cuneiform tablet*, The Metropolitan Museum of Art, New York, accession no. 1988.433.3; p. 8 right: *Hieratic Papyrus fragment (reign of Ramesses III)*, The Metropolitan Museum of Art, New York, accession no. O.C.3569; p. 9 left: *Scribes from Meketre's Model Granary (early reign of Amenemhat I)*, The Metropolitan Museum of Art, New York, accession 20.3.11-SCRIBES; p. 9 left: *Votive stela of Userhat (late Dynasty 18)*, The Metropolitan Museum of Art, New York, accession no. 05.4.2; p. 12: *Neo-Assyrian Relief panel*, The Metropolitan Museum of Art, New York, accession no. 17.190.2080; p. 13 left: *Layperson and monk jointly making books in Echternach Abbey* (Bremen, Universitätsbibliothek, MS 217, c. 1020); p. 13 left: *Manuscript Illumination with Crucifixion in an Initial T, from a Missal, Made in Avignon, France*, The Metropolitan Museum of Art, New York, accession no. 28.140; p. 14 left: *The Tudor Pattern Book*, The Bodleian Library, Oxford. Shelfmark MS. Ashmole 1504; p. 14 right: *Il Taccuino di Giovannino de' Grássi*, Biblioteca Civica Angelo Mai, Bergamo; p. 15 left: Vítězslav Nezval, *Abeceda; Taneční Komposice Milča Mayerové*. Prague: J. Otto, 1926; p. 15 right: *The letter 'L' from a set of 26 prints, from The Alphabet Suite*, c. 1976-1977, Erté (Romain de Tirtoff, 1892-1990)/Private Collection ©Christie's Images/Bridgeman Images and ©Sevenarts Ltd/DACS 2018; p. 16 top: Edward Benlowes: *Theophila* (with etchings by Francis Barlow), 1652, in the collection of Chetham Library, Manchester; p. 16 bottom: Anon., *Alphabeth de la Bourbonnoise*. France, 1789, from the Library of Congress, Washington, item no. 2007685768; p. 17 top: *The Comical Hotch-Potch, or the Alphabet Turn'd Posture-Master*, Print by Carington Bowles, 1782; Granger Historical Picture Archive/Alamy Stock Photo; p. 17 bottom left: Anastasia Mastrakouli, *Naked Silhouette Alphabet*, 2012, reproduced with permission; p. 17 bottom right: Anthon Beeke's *Naked Ladies Alphabet*, 1969 (later renamed *Body Type*), reproduced with permission.

BACKSTAGE PHOTOS: (pps. 4, 75, 77-79 and 82): the cast and crew.

EDITORIAL: Mona Gainer-Salim

PRODUCTION: Num Stibbe

DESIGN: Ornan Rotem

Set in Monotype Centaur, a modern Renaissance-inspired typeface by Bruce Rogers (1870–1957) harking back to the books of the great Venetian printer Nicolas Jenson (1420–1480). The italics were drawn by Frederic Warde (1894–1939), who took inspiration from Ludovico degli Arrighi's 1524 landmark italic type.

PRINTED BY Trifolio srl, Verona

Text on Gmund Lakepaper Blocker, 135 GSM FSC® certified (FSC-C006462)

BINDING Van Warden b.v., Amsterdam

First Edition

ISBN: 978-1-909631-29-8

SYLPH EDITIONS
London · 2018
www.sylpheditions.com

The
End

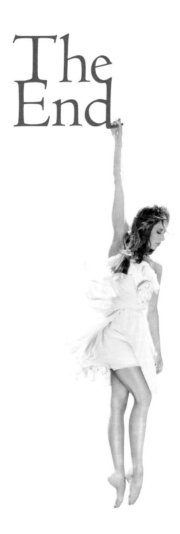